IMAGES
of America

JAMESTOWN
EXPOSITION
AMERICAN IMPERIALISM ON PARADE
VOLUME II

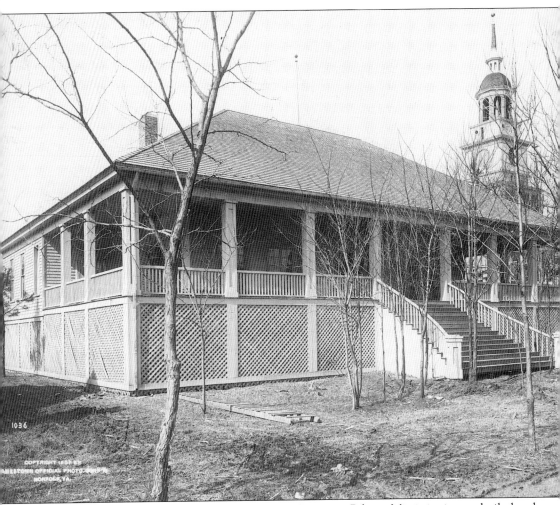

Beauvoir, a replica of the home of Jefferson Davis in Biloxi, Mississippi, was built by the Virginia Division of the United Daughters of the Confederacy. The house was located at the west end of Commonwealth Avenue in full view of Hampton Roads and very near the Virginia and Maryland Buildings. Construction was begun on December 24, 1906, and since time was critical, work proceeded despite poor weather and holidays in order to have the replica Beauvoir ready for the opening day of the exposition. Mrs. Frank A. Walke was in charge of the house's construction. The original Beauvoir is the home in which Davis penned his tome, *The Rise and Fall of the Confederacy*.

IMAGES
of America

JAMESTOWN
EXPOSITION
AMERICAN IMPERIALISM ON PARADE
VOLUME II

Amy Waters Yarsinske

ARCADIA
PUBLISHING

Published by Arcadia Publishing
Charleston SC, Chicago IL, Portsmouth NH, San Francisco CA

Printed in the United States of America

Library of Congress Catalog Card Number: 99-62632

For all general information contact Arcadia Publishing at:
Telephone 843-853-2070
Fax 843-853-0044
E-mail sales@arcadiapublishing.com
For customer service and orders:
Toll-Free 1-888-313-2665

Visit us on the Internet at www.arcadiapublishing.com

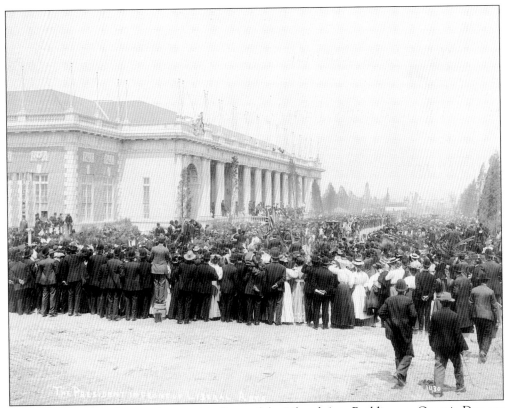

President Theodore Roosevelt passed in front of the Liberal Arts Building on Georgia Day, on his way to the grandstand.

CONTENTS

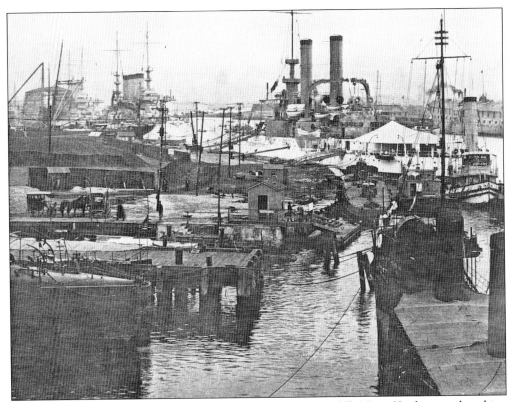

Battleships were moored alongside the coal piers at the Norfolk Navy Yard, second-ranking United States Navy facility in 1907, when an unknown photographer took this picture. The destroyer, USS *Stewart* (DD-13), painted white, hallmark of all the Great White Fleet vessels, is in the foreground, and the receiving ship, USS *Richmond*, may be seen across the Elizabeth River. The *Stewart*'s commanding officer at the time of the around-the-world cruise was Lieutenant J.F. Hellwig. The fourth, *Mohawk*, a first-class steel revenue cutter, rests next to the pier on the far right, its bow facing the reader. The *Stewart*'s keel was laid on January 24, 1900, at Morris Heights, New York, by the Gas Engine and Power Company, and launched on May 10, 1902. *Stewart* was commissioned on December 1, 1902, and placed under the command of Lieutenant Frederick A. Traut. Though *Stewart* was commissioned and served a brief period at the United States Naval Academy, she was subsequently placed in the Coast Squadron of the North Atlantic Fleet. The destroyer was transferred to the reserve at Norfolk but later recommissioned in 1907 in the Atlantic Fleet, hence the reason for *Stewart* appearing in this photograph from the year of the exposition at Norfolk Navy Yard. After rejoining the active fleet, *Stewart* was sent to the Pacific Fleet but soon became an outdated symbol of her ship class. *Stewart* had been one of the first destroyers ever built by the United States. On February 24, 1916, *Stewart*, as one of the destroyers numbered 1 through 16, was reclassified as a coast torpedo vessel. By September 15, 1919, *Stewart* was struck from the Navy record, and she was sold for scrap on January 3, 1920. The *Mohawk* was built in Richmond, Virginia, and commissioned on May 10, 1904. Though the cutter was based in New York, *Mohawk* went up and down the Atlantic coast, her primary duties assisting vessels in distress and enforcing navigational laws. The *Mohawk* was transferred on a temporary basis to the Navy on April 6, 1917, and was unfortunately struck and sunk by a merchant vessel on October 1, 1917, off Sandy Hook, New Jersey. The USS *Richmond* was originally a wooden frigate built for the Navy at Norfolk, Virginia, in 1858. At 225 feet long and 42.6 feet wide, *Richmond*'s hull was subsequently used to convert her to a receiving ship and auxiliary to the *Franklin* at Norfolk.

INTRODUCTION

The powerful naval presence at the exposition, the event's grand finale, was attributable to the splendor of the American Battle Fleet, dubbed the Great White Fleet, under the command of Rear Admiral Robley D. "Fighting Bob" Evans. The historic Hampton Roads fleet of 16 first-line battleships and support vessels was comprised of four divisions, each commanded by a rear admiral. The first division consisted of the *Connecticut, Kansas, Vermont,* and *Louisiana.* The second was led by the *Georgia, New Jersey, Rhode Island*, and *Virginia.* Then came the third division with the *Minnesota, Ohio, Missouri,* and *Maine,* followed by the last group made up of the *Alabama, Illinois, Kearsarge,* and *Kentucky.* President Theodore Roosevelt reviewed his fleet from the presidential yacht, the *Mayflower,* as the fleet passed through Hampton Roads on December 16, 1907. The *Connecticut* served as Evans's flagship. The "fleet that went 'round the world" returned to Hampton Roads on February 22, 1909, under the command of Rear Admiral Charles S. Perry, who relieved Evans when the fleet departed the West Coast on its tour of the Pacific. President Roosevelt was on hand to review the return of one of the world's greatest displays of naval power, the Great White Fleet.

The Jamestown Exposition attracted a fair number of visitors from its opening day until the time it closed in December of 1907. From what has been recorded of the event, the numbers were not as high as the organizers would have liked. Within a few months after the cessation of festivities, the Jamestown Exposition development was in financial trouble. The "world's fair" at Hampton Roads had been a financial failure, though it is believed that the exposition brought great prestige to Hampton Roads, including Norfolk, when the city's population was burgeoning. Property values north of Colonial Place, in Larchmont for example, began to increase at a feverish pace. Within a decade after the grand celebration of the tercentennial of the Jamestown settlement, a United States District Court judge ordered the land and buildings sold by an appointed commission of the court. Fidelity Land and Investment Corporation bought the property for $235,000 and, later sold $100,000 of land included in their original purchase. States had sold their buildings to individuals while the rest was offered to Fidelity, which then turned around and sold them to individuals and Norfolk real estate companies. Since the location of the properties was ideal for naval forces, and the United States Navy liked the site, a bill was sent before Congress in 1908 to purchase the land for a million dollars, including the buildings. The bill failed to pass through Congress.

Construction was ongoing on the exposition grounds through October 1907, within a month of the event's closing on November 30, 1907, which was part of the problem. When the world's fair in Hampton Roads concluded, many of its state buildings were used as private residences, earning them the name state "houses," while others fell almost immediately into ruin and some to catastrophic fire. As early as 1912, Norfolk officials proposed that the United States Navy assume responsibility for the property previously occupied by the exposition and now dotted with what remained of one of the twentieth century's greatest exhibits of American history. The Navy rejected the idea in 1912. From the time the Navy and United States Congress rejected the initial purchase of land at Sewell's Point to about 1917, the Jamestown Exposition

buildings and grounds had gone into slow decay, making the property less desirable to potential private-sector buyers. Theodore J. Wool of Fidelity had failed again, in 1914, to sell the site to the Navy. Even in 1917, Navy Secretary Josephus Daniels remained uninterested in the location since the United States had not yet entered the First World War. It was not until April 6, 1917, after the United States went to war, that Daniels contacted Wool to arrange a lease of the land and buildings. The seagoing service, succumbing to the pressures of America's entry in World War I, had little choice but to hastily construct the precursor to today's Naval Base Norfolk.

Captain (later Admiral) J.E. McLean conferred with Wool, and eventually, the secretary of the Navy was convinced that buying the property was the most prudent option available to the Navy. A bill to purchase 474 acres for the naval station passed both the United States House of Representatives and the United States Senate without incident. President Woodrow Wilson signed the bill into law on June 15, 1917. Of course, since all the state buildings on the former exposition grounds were owned by individuals at that time, the Department of the Navy made arrangements with each owner to buy the properties. In 1934, the state buildings located at the eastern edge of the exposition grounds were, as government documents record, moved west just a few hundred yards from the old Chambers Field at Naval Air Station Norfolk.

Organizers of the Jamestown Exposition, including officials and politicians tied to the United States government, might have heeded the protests of a prestigious group of academic, religious, and political leaders who were against the exposition being turned into a show of American militarism, an aspect fraught with expense and political problems. In an official paper dated January 4, 1907, the group, consisting of the Honorable Carroll Davidson Wright (1840–1909), an educator and the first commissioner of the United States Bureau of Labor, from 1885 to 1905; Edwin D. Mead; Reverend Edward Everett Hale (1822–1909), a religious leader and author, his books covering a wide range of popular causes and reforms; Cardinal James Gibbons (1834–1921), former bishop of Richmond, in 1872, later made archbishop of Baltimore, he was also the founder and first chancellor of Catholic University, and appointed only the second American cardinal by Pope Leo XIII; John Mitchell; Jane Addams (1860–1935), a social reformer more often associated with woman suffrage; Martha Carey Thomas (1857–1935), an educator and feminist, best known as a professor of English and dean at the newly opened Bryn Mawr College for women, where she was the first woman college faculty to hold the title of "dean"; William Couper; Professor James H. Dillard; Joseph Lee; J. Howard McFarland; Frederic Allen Whiting; Professor C.M. Woodward; Professor Charles Zueblin; and members of the exposition's advisory board, in strong language, called for the United States government to atone for its grievous mistake in pushing military power over issues of education, labor, and social economy at the exposition in Hampton Roads. The authors of the document wrote the following: "The extravagant militarism of the programme of the coming Jamestown Exposition, as developed and disclosed during the last few months, is a profound shock to a great body of the American people."

The Jamestown Exposition organizers had earlier published an official list of attractions of the coming exposition, which, as pointed out in the protest of January 1907, was a 38-item list, and 18 of these were, according to the protest paper, as follows: "1) Greatest military spectacle the world has ever seen; 2) Grandest naval rendezvous in history; 3) International races by submarine warships; 4) Magnificent pyrotechnic reproduction of war scenes; 5) Reproduction of the famous battle between the *Monitor* and *Merrimac* [sic] at the place where that battle was fought; 6) Great museum of war relics from all nations and all ages; 7) Greatest gathering of warships in the history of the world; 8) Prize drills by the finest soldiers of all nations and by picked regiments of United States and State troops; 9) Races of military airships of different nations; 10) The largest military parade ground in the world; 11) Contests of skill between soldiers and sailors of different nations; 12) Daily inspection of warships in the harbor and troops in camp; 13) The greatest military and naval parade ever witnessed; 14) More naval and military bands than were ever assembled in time of peace; 15) Greatest array of gorgeous

military uniforms of all nations ever seen in any country; 16) More members of royalty of different countries than ever assembled in peace or war; 17) The grandest military and naval celebration ever attempted in any age by any nation; and 18) A great living picture of war with all of its enticing splendors." Carroll Davidson Wright *et al.* were deeply resolved that the Jamestown Exposition, unveiled months prior to its opening day, was much different than the one envisaged at the event's conception. Wright and his colleagues quickly concluded though "an international naval and military celebration was to have a conspicuous place in the Exposition's programme, as provided for by Congress in granting aid for that purpose in 1905," and that this fact was well known, their objection was centered on the plan to make the exposition primarily "a naval and military spectacle," bent on intoxicating "the American people for six months by a 'great living picture of war with all of its enticing splendors,'" and by encouraging this level of pageant and sport, the government was avowing war as acceptable so long as American interests were at stake. The criticisms of this group were well founded.

As late as June 1906, the proposed character of the Jamestown Exposition was being described, according to the paper written by Wright *et al.*, as "fittingly observed: first, by emphasizing the great historical events that have marked the progress of America from the first settlement; second, by an industrial exhibition primarily of American skill and art; and, third, by an international military, naval, and marine celebration." Yet, in accordance with the same source, the following month, the complexion of the exposition changed abruptly. The intended scope of the exposition had become the following: "1) A great international naval and military assemblage, inaugurated and controlled by the United States government; 2) An Exposition inaugurated and controlled by the Jamestown Exposition Company," which continued to pursue exhibits pertaining to history, art, education, and the like. The protest against "the reproduction in Hampton Roads on such an occasion of one of the tragic battles of our Civil War, as a spectacle to attract and amuse a crowd of careless spectators, is a thing greatly to be deprecated," referring to the Battle of the *Monitor* and *Merrimac* [sic], located on the War Path. The Civil War was still a tender subject for Americans a little over 40 years after its end. In September of 1906, the pervasive theme of the Jamestown Exposition had turned from historic to military. "The Exposition will be primarily a military and naval celebration, commercialism being relegated to the rear, but certain industrial features will play an important part in showing the progress of art, science, and the great inventions and improved methods of the present." Adding to the protest was the fact that the exposition would have not only every branch of the United States Army represented, but nearly every state provided troops who would encamp and parade on the exposition's grounds. For the first time in the history of an American exposition, the policing of the event was done by soldiers of the United States Army and militia units from various states. Wright *et al.* noted that "The presence of foreign troops, hitherto forbidden in the republic, will be a marked and exciting feature. 'The United States has never hitherto permitted armed companies of foreign soldiery to visit this country. Consequently, for the first time Americans will see an international encampment, and the size of this one may be imagined when we realize that almost every foreign country will send one of its crack regiments.'"

In the end, Carroll D. Wright and his band of protesters wrote the following: "The impressive fact cannot be forgotten, nor the mournful contrast fail to be marked, that the inaugural exposition at London in 1851, in the great series of international expositions now eventuating in America in a celebration of war, was conceived in England expressly as a Festival of Peace, a greeting of the dawn of an era of industrialism to supplant the old era of militarism, a pledge and celebration of fraternity and cooperation among the nations." Youthful America might have, they suggest, learned something from their aged parent, the parent early English settlers at Jamestown and Massachusetts Bay later decried for oppressive policies. Wright *et al.*'s paper remarked, "The noblest ambition of the present Liberal government of England, the mother country of the race whose advent in America it is proposed to celebrate by 'the greatest military spectacle the world has ever seen,' is to place England at the head of a movement to unite the

great influential powers in a League of Peace. The prime minister of England, Sir Henry Campbell-Bannerman, in his opening speech at the recent Interparliamentary Conference at Westminster, said: "The reasoned opinion of Europe is declaring itself more and more strongly for peace. Is it not evident that a process of simultaneous and progressive arming defeats its own purpose? Scare answers to scare, and force begets force, until at length it comes to be seen that we are racing one against another after a phantom security.' " The Jamestown Exposition, in an ironic twist, opened at the same time that representatives of many countries met at The Hague for the second International Peace Conference.

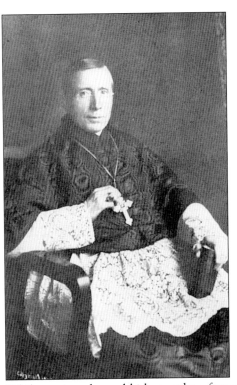

Cardinal James Gibbons was born in Baltimore, Maryland, on July 23, 1834, son of Irish immigrant parents who returned to Ireland with their young son when he was three years old. Gibbons spent his youth in Ireland but returned to the United States in 1852, settling in New Orleans with his mother. He was ordained a priest in the Roman Catholic Church in 1861. During the American Civil War, Gibbons was the pastor of a small parish and served as a chaplain at Fort McHenry. It was during the war that Gibbons saw the horrors and destruction that would later play prominently in his protests against militarism. He ministered at many field hospitals, witnessing the carnage first-hand. His charisma and extraordinary capabilities advanced him quickly through the church's hierarchy. He served as assistant chancellor of the Second Plenary Council for the Roman Catholic Church in America in 1866 and was named Vicar Apostolic of North Carolina two years later. By 1871, Gibbons had been appointed the Bishop of Richmond, and there he remained until May 20, 1877, when he was named the Coadjutor Archbishop of Baltimore. While serving the archbishop only a few months, Gibbons was designated his successor on October 3. As archbishop of Baltimore, Gibbons presided over the Third Plenary Council of the Roman Catholic Church in America in 1884. He was ultimately appointed the second American cardinal by Pope Leo XIII. Gibbons was the founder and first chancellor of Catholic University, which opened in 1889 in Washington, D.C. He was broadly popular beyond the confines of the Roman Catholic Church, and it is known that Gibbons counseled several United States presidents during his lifetime, regardless of a president's political and religious affiliations. Gibbons passed away in Baltimore, Maryland, on March 24, 1921. The photograph shown here was taken c. 1907 and was used by the Jamestown Exposition to depict the wide range of personalities and political figures who were involved with the event.

One
DAYS, PLACES, AND
PEOPLE TO REMEMBER

"When present times look back to ages past,
And men in being fancy those are dead,
It makes things gone perpetually to last,
And calls back months and years that long since fled.
It makes a man more aged in conceit."
—From *Contemplations*, 1664–1665?
Anne Bradstreet, American poet (1612–1672)

The Davy Crockett Fire Company, of Poughkeepsie, New York, was photographed in front of the Powhatan Oak.

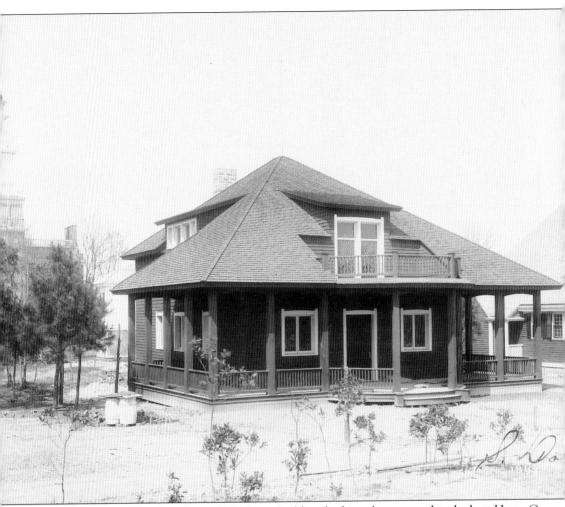

Construction of the Grand Trunk Railway Building had just been completed when Harry C. Mann took this photograph. The replica station was built by the Grand Trunk Railway System of Canada. Canadian participation in the exposition, in addition to the quality of the railway's exhibit, was due in large measure to the work of G.T. Bell, the general passenger agent of the Grand Trunk. The building was a pleasing blend of Dutch and Colonial architecture with wide shady porches and vaulted ceilings. The railway had artwork and photographs hung on the first floor, depicting landscapes that rail passengers might have seen when riding the company's track. At the time of the exposition, the Grand Trunk was the longest continuous double-track system under a single management.

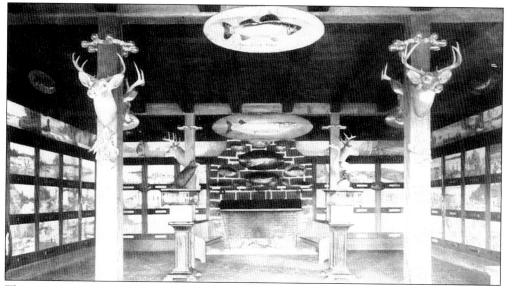

The interior of the Grand Trunk Railway Building was supplemented by a set of hand-colored photographs that formed a frieze. The frieze depicted sporting scenes and locations in Canada, but particularly Ontario, popular with outdoorsmen. There were also mounted specimens of fish and game, the oak plaques bearing maskalonge, wall-eyed pike, bass, and pickerel, to heads of elk, moose, deer, and birds. This was one of only two exhibits from Canada, the other originating with Nova Scotia.

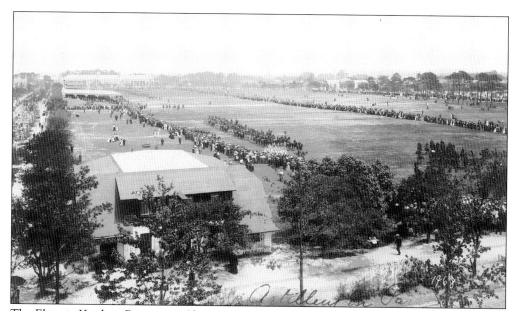

The Electric Kitchen Restaurant (foreground), located at the northwest end of Lee's Parade, is shown here during an artillery demonstration. Nellie F. Conway catered the food served at the Electric Kitchen.

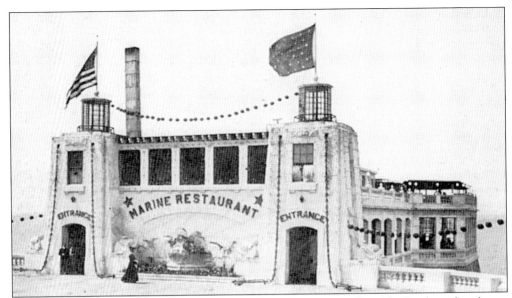

The Marine Restaurant was located on the waterfront, facing Willoughby Boulevard and near the Government Pier, opposite Pennsylvania House and some of the government buildings. The restaurant extended into the Hampton Roads roadstead and was the first-class cafe of the exposition. Nathan, Grandall & Hamburger operated the restaurant, which was built on piles and at high tide was surrounded by water on three sides. Many elegant banquets were held in this location, meals often accompanied by the sweet refrain of orchestral music provided by the Marine Orchestra, clad in the uniform of sailors.

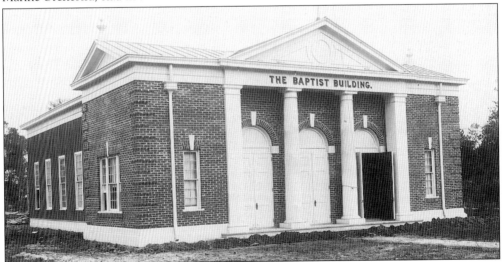

The Baptist Building was one of two exhibit structures built by a Protestant denomination; the other was erected by Presbyterians. The Baptist Building was the direct result of a resolution offered at a conference of Baptist pastors of Norfolk and Portsmouth, Virginia, held in Norfolk in February 1905. The Reverend R.B. Garrett, D.D., pastor of Court Street Baptist Church, of Portsmouth, put up the resolution, and he subsequently chaired the original commission, serving in that role for the duration of the Jamestown Exposition. The building was located near the west entrance of the exposition. Distinguished visitors to the Baptist hall included two Baptist governors, Charles Evans Hughes, of New York, and Joseph Wingate Folk, of Missouri.

William Jennings Bryan was a political figure and two-time presidential candidate, born in Salem, Illinois, on March 19, 1860. As a young lawyer he moved to Lincoln, Nebraska, where he eventually became part of the American political scene, speaking often to issues that were of great importance to people across the United States. He was elected to the House of Representatives as a Democrat from a Republican-majority district of Nebraska. His reelection in 1892 was his last successful bid for public office. He won his party's nomination for president of the United States in 1896, with his "Cross of Gold" speech. He lost the general election and, undaunted, ran again in 1900, but lost to William McKinley.

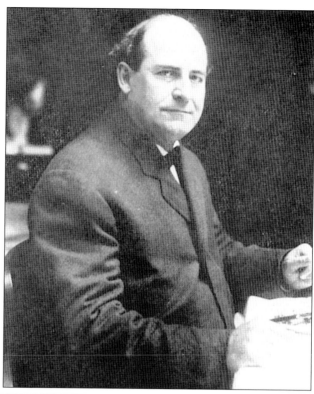

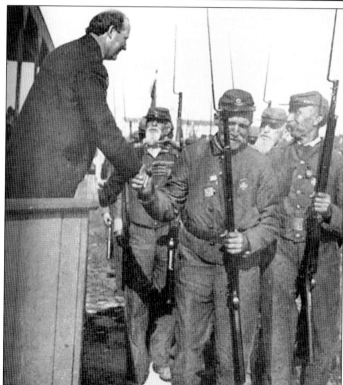

Bryan was the guest speaker for Patrick Henry Day at the Jamestown Exposition, held on May 30. The photograph shown here pictures Bryan greeting members of the First Tennessee Regiment Reserves, consisting entirely of Confederate veterans of the Civil War.

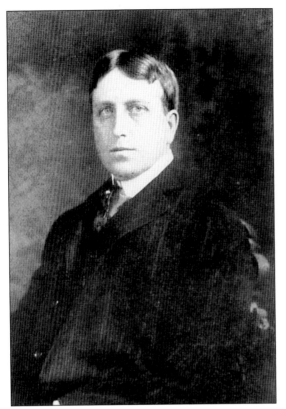

National labor issues were not ignored at the Jamestown Exposition. On September 2, Labor Day on the grounds, William Randolph Hearst (1863–1951), pictured here, was one of the featured speakers in the Auditorium. In his speech, Hearst advocated the position of union laborers, noting that "prosperity for the producing classes means prosperity for the commercial classes. It means prosperity for me as a newspaperman. It means prosperity for every businessman." Though he defended all labor organizations, he repudiated the undermining and unlawful actions of some union leaders. Hearst was, understandably, one of the most controversial figures in the labor fights of the early twentieth century.

William Randolph Hearst was followed on the podium by Samuel Gompers (1850–1924), a union leader, who declared, "The American workman stands erect, looking his fellow man squarely in the eye, insistent upon his just demands, as the equal of all his fellows, striving, aspiring to the highest development of justice among men." Of the labor union, Gompers added, "Out of all the struggles of the past, the labor movement of our time represents the best expression of the aspiration for the future. It aims to make today a freer and a better one than it was yesterday."

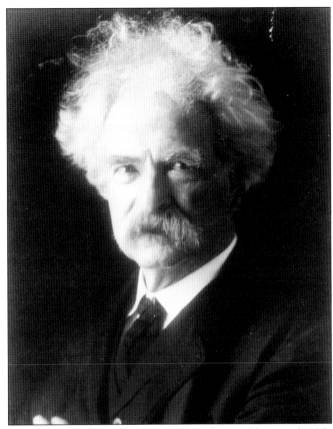

Famous American humorist and novelist Samuel Langhorne Clemens (1835–1910), popularly known by his pen name Mark Twain, was one of the most popular orators to set foot on the Jamestown Exposition grounds. On Robert Fulton Day, September 23, the centennial celebration of the invention of the steamboat, Mark Twain was on hand to honor Fulton (1765–1815), who designed and built the first commercially successful steamboat in 1807. Arriving aboard the yacht, *Kanawha*, Clemens (Mark Twain) proceeded with other dignitaries, including Cornelius Vanderbilt, Hugh Gordon Miller, originally of Norfolk and later New York City, and Rear Admiral Purnell F. Harrington, to the Auditorium where Robert Fulton Cutting, of New York, gave a brief address and concluded with an introduction of Mark Twain as chairman and master of ceremonies for the day's commemoration. Following Twain's remarks, the venerable humorist turned over the floor for addresses by Harry St. George Tucker, Lieutenant Governor of Virginia J. Taylor Ellyson, Miller, and Harrington. Twain then proceeded to introduce Martin W. Littleton, of Brooklyn, New York, the featured speaker. Robert Fulton Day included a spectacular assemblage of every sort of steam-powered craft in Hampton Roads, just off the exposition grounds. The vessels, of all sizes and description, were bedecked in flags and bunting, and formed a maritime parade reviewed by guests from the decks of visiting yachts. President Theodore Roosevelt, King Edward VII, of England, and Sir Thomas Lipton awarded cups for winners in various classes of yacht races. As an aside, Harrington was in charge of the United States Navy's participation in the exposition. Clemens did not introduce Harrington other than to acknowledge his assistance. Clemens's participation in the day's events was not, contrary to recent reporting, an attempt by the author to get a free meal for his participation. As ill as Clemens was in the waning years of his life, the event that drew his participation had to be fairly substantial and its purpose relevant to Clemens's interests. (Photograph courtesy of the Library of Congress, *c.* 1907.)

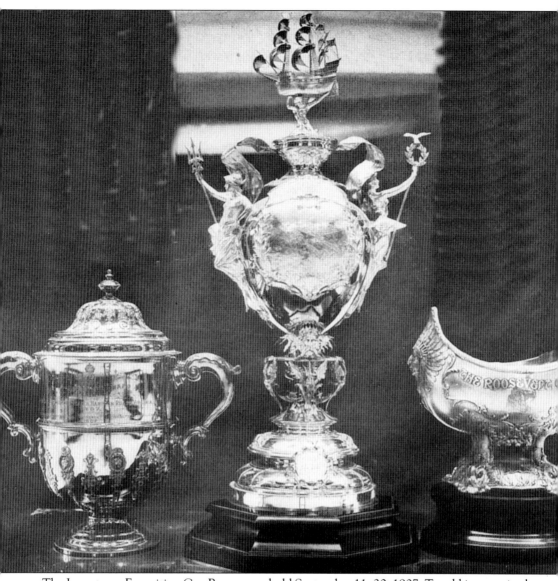

The Jamestown Exposition Cup Races were held September 11–20, 1907. To add interest in the yacht races scheduled for the exposition, four fine loving cups were offered as prizes, three of which are shown here. The King's Cup (left) was donated by His Majesty, King Edward VII of England; the President's Cup, donated by President Theodore Roosevelt (right); and the Sir Thomas Lipton Cup, donated by Lipton, a well-known sportsman and tea magnate. The Jamestown Exposition Cup, not shown, rounded out the trophies awarded to the winners of the races. The *Sue*, owned by Edwin R. Luckenbach of New York, won the President's Cup. The *Manhasset*, owned by Clarence Robbins of the Manhasset Yacht Club of Long Island, New York, took home the King's Trophy, and the Jamestown Exposition Trophy went to the *Little Rhody* of Providence, Rhode Island. The *Elanor* of Boston, Massachusetts, owned by F.W. Fabyan, won the Lipton Cup.

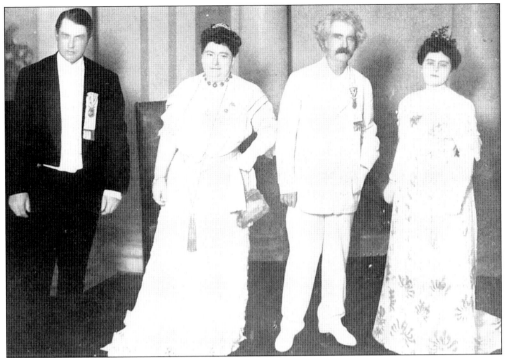

The picture shown here of Clemens was taken on Robert Fulton Day and included (left to right) Hugh Gordon Miller, Mrs. Donald McLean, Samuel Langhorne Clemens, and Mrs. Hugh Gordon Miller. Hugh Gordon Miller was a member of the New York Commission sent to the exposition. Mrs. Donald McLean was also a New York commissioner and president-general of the Daughters of the American Revolution.

The Best-Known American of His Time—By Any Name

Samuel Langhorne Clemens, known more widely by his pen name, Mark Twain, was familiar with life in the frontier towns that dotted the shoreline up and down the Mississippi River. He was born on November 30, 1835, in Florida, Missouri, an inland village, son of John Marshall Clemens, who had migrated from Virginia to Kentucky then on to Tennessee, where he married a woman named Langhorne, daughter of a wealthy and influential man from Adair County. Young Samuel's parents had been restless pioneers, moving from Tennessee into Missouri, then south to Monroe County, Florida, and finally to Hannibal, Marion County, Tennessee, a riverport buzzing with activity, in 1838. The move to Hannibal has been said to have been the leaping off point in Clemens's life, providing a rich backdrop for stories later to flow from his imagination onto paper. Steamboats provided him endless adventure, not to mention his pen name. For those unfamiliar with how young Clemens came upon his famous nom de plume, the story goes that as the steamers approached the wharf, the crewmen would take soundings of the water depth so as not to run aground. The pilot of the boat would call out "mark twain" to inform the crew of the water's deepness. Clemens was so taken with the steamers and the river that he actually learned to be a river pilot, among other trades he would develop in his lifetime. Clemens himself might have contested the origin of his pen name. The *New York Times* of June 17, 1877, ran a piece from the *San Francisco Alta* pertaining to how Clemens came by the nom de plume. The snippet was an excerpt from a letter Clemens wrote

to John A. McPherson, a resident of San Francisco, on the subject. Clemens wrote the following: " 'Mark Twain' was the nom de plume of one Captain Isaiah Sellers, who used to write river news over it for the *New Orleans Picayune*. He died in 1863, and as he could no longer need that signature, I laid violent hands upon it without asking permission of the proprietor's remains. That is the history of the nom de plume I bear. Yours truly, (signed) Samuel L. Clemens, May 29." Regardless of how he came by that irascible name, there was no better man to pay homage to the great Robert Fulton than the irreplaceable Samuel Clemens, a.k.a. Mark Twain.

Upon Clemens's death on April 21, 1910, a little over three years after his appearance in Hampton Roads, the best-known American man of letters, often referred to as the "Dean of American Literature," was eulogized by his friends and fellow Americans, who remembered his life with the richness and humor with which he lived. Of his humor, F. Hopkinson Smith, Clemens's friend of 30 years, remarked, "Humor, to be lasting, must be clean. Clemens's humor was essentially clean. It will be lasting for that reason. It was the humor of human nature." Smith also noted of one of Clemens's most famous characters, Tom Sawyer, "Twain did not make fun of Tom Sawyer painting the backyard fence. He brought out the human note in the boy. And that's what makes us always remember that passage with joy and read it over and over." Perhaps one of his editors at Harper & Brothers, Henry M. Alden, captured Clemens's life best when he said, "Nobody could tell anything about Mark Twain better than he could tell it himself—or; indeed, half so well. He has always been writing his autobiography. I have always believed that literature has lost much by not having had more of his imaginative creations on a higher plane." Robert Underwood Johnson, later the American ambassador to Italy, would further write in *The Book News Monthly* of April 1910 that "Mark Twain was, with one exception, the best-known American of his time, and, without exception, outside of Poe [Edgar Allan (1809–1849)] and the New England school, he was our most distinguished writer. He had the singular distinction of having, so to speak, naturalized American humor in many lands." Clemens's humor was not complicated, relying on the basic tenets of human nature, a quality that led one of his fellow Americans, James Whitcomb Riley, to comment, "The world has lost not only a genius, but a man of striking character, of influence, and of boundless resources. He knew the human heart and he was sincere. He knew children, and this knowledge made him tender."

Robert Fulton was honored with a number of essays written by young people from across the commonwealth, many of which were placed on display. This one, a page of which is shown here, was written by Mary Cunningham, a fifth grader at Syms-Eaton School in Hampton, Virginia. Mary was 12 years old and penned her submission on March 22, 1907.

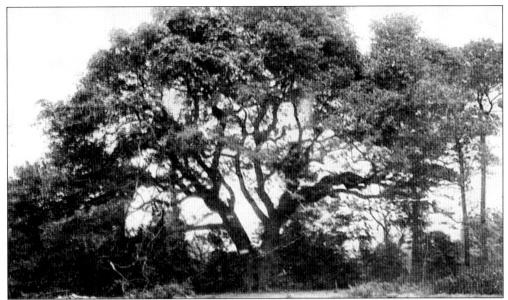

The Powhatan Oak, depicted here on a postcard from 1907, was the largest and oldest oak on the exposition grounds, and stood in an area east of Bainbridge Avenue and north of Gilbert Street. Though it was removed decades ago because the tree had purportedly become diseased, the process of its extraction unearthed human remains, long ago caught in the grip of its roots. The remains found entangled in the roots were tentatively identified as belonging to a Native American and reburied on the same spot in a coffin. The only large live oak, *Quercus virginiana*, left standing on Naval Base Norfolk property is the Willoughby Oak. This tree is the third largest on record in Virginia and estimates place its age between 500 and 600 years old. Its co-champion trees are located in Forest Lawn Cemetery in Norfolk and Fortress Monroe on Virginia's Peninsula. In 1942, Rear Admiral Manley H. Simons, commander of the base, stated that the Willoughby Oak was to be protected at all times.

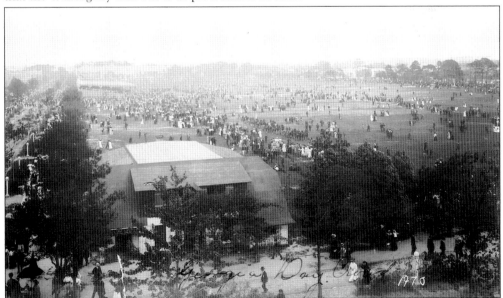

The Georgia Day crowd far exceeded most of the state day attendance figures for the exposition.

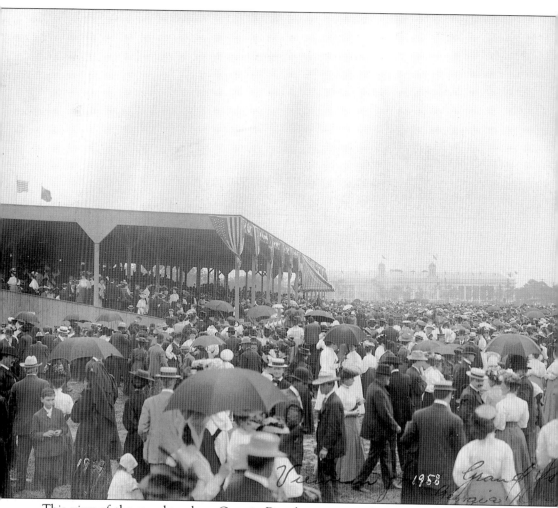

This view of the grandstand on Georgia Day demonstrates the magnetic draw of President Theodore Roosevelt and his entourage. Crowds pressed close to the stand to catch a glimpse of their president. (Harry C. Mann, photographer.)

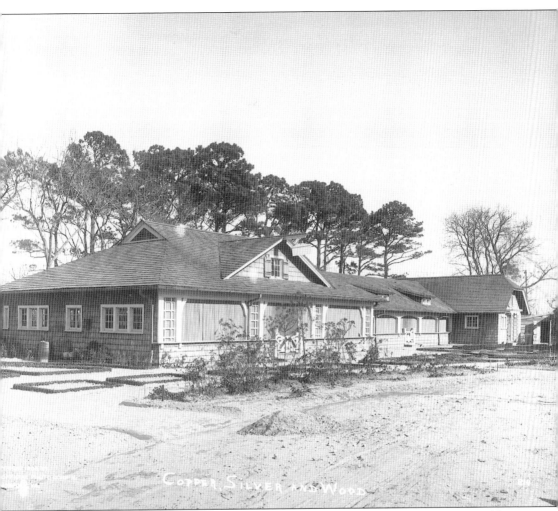

The Copper, Silver and Wood Building, located in the Arts and Crafts Village, was occupied by Virginia Polytechnic Institute and State University. This was actually one of four buildings occupied by Virginia Polytechnic Institute and State University at the Jamestown Exposition. In early 1906, Virginia Polytechnic Institute secured 500 square feet of exhibit space in the Palace of Education, but by January of the following year, exposition officials offered to turn over the Copper, Silver and Wood Building to the university, the largest building in the Arts and Crafts Village. The university found the building too small for its displays so it also obtained another large building in the same area, but finding even with this space there would be limitations, Virginia Polytechnic Institute faculty and administration secured a third building in the village. When the director of dairy husbandry discovered that he would not have enough room to display his department and have sufficient room to sell dairy products, a fourth building was acquired for agricultural exhibits. The university's showing at the exposition was considered outstanding.

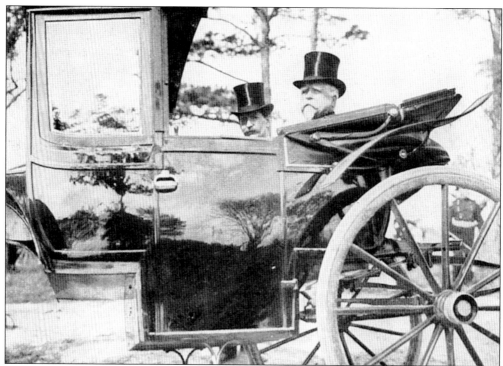

Governor of Maryland Edwin Warfield and Governor of Virginia Claude A. Swanson were photographed in the Virginia governor's carriage on the way to the Virginia Day celebration, September 19, 1907. Notice the landscape of the exposition reflected in the polished surface of the coach.

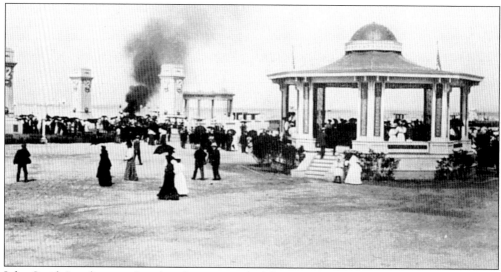

John Smith Landing was found at the inner end of the Grand Basin, close to the foot of Raleigh Court where steamers and other vessels fed waterborne passengers in and out of the exposition.

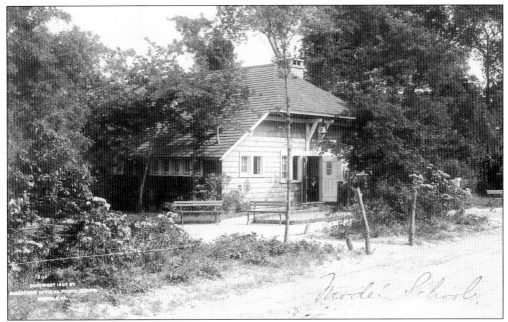

The Model School was located on Spottswood Avenue across from the States' Exhibit Palace.

The Old Jamestown Building was a historical reproduction of Virginia subjects from the early settlement period.

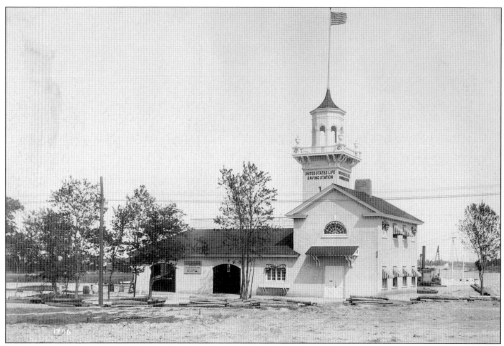

The United States Life Saving Service built and operated a state-of-the-art station, fully manned and under the care of an experienced keeper. Twice a day, the station's crew conducted drills for the public at the edge of Boush Creek.

The simple beauty and pleasures of the Jamestown Exposition grounds set it apart from other expositions and world fairs. The blackberries trained on this barbwire fence looked enticing enough to pick, but a sign at the end of the fence-post forbade that kind of indulgence—or temptation.

The athletic field was built to support the various sporting events held during the exposition. The field was not completed when this picture was taken by Harry C. Mann in early 1907. The National Amateur Athletic Union (AAU) Championships were held at the exposition on September 6–7, 1907.

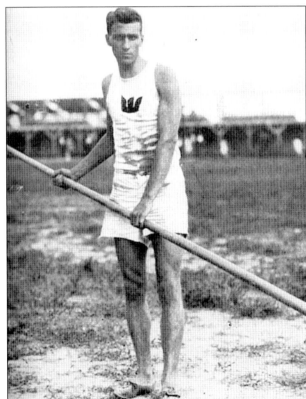

E.T. Cook Jr., of the Irish-American Athletic Club, was competing in the AAU pole vaulting event when Harry C. Mann took this picture.

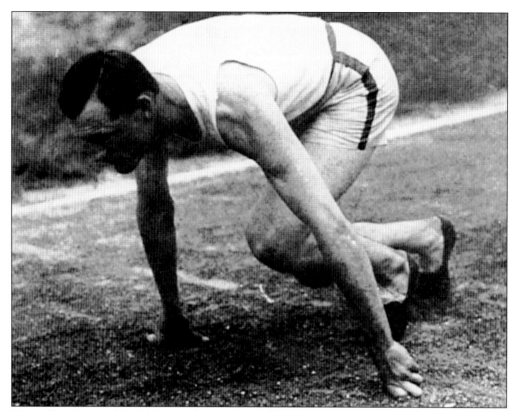

Forrest Smithson, of the Multnomah Amateur Athletic Club, pictured above before the start of a hurdle race, was photographed as he won the 110-meter hurdle race during the National AAU Championships. His winning time was 15.35 seconds. Smithson was a track star without peer. He established the first official world record of 15.0 seconds and won the gold medal on July 27, 1908, at the Olympics in London. His record, recognized as the most durable world record in the event by the International Amateur Athletic Federation (IAAF), lasted until 1920, when it was broken by Earl Thomson, of Canada, who ran the 110-meter hurdles in 14.4 seconds, the first record under 14.5. Thomson set the record in Antwerp, taking home the gold medal. The Multnomah Amateur Athletic Club was located in Multnomah County, Oregon.

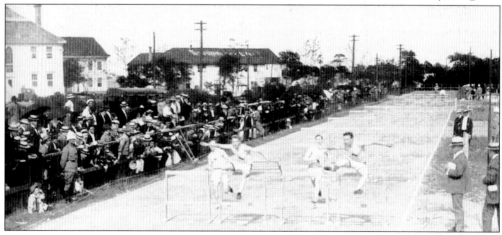

Two

THE BLACK JAMESTOWN EXPOSITION COMPANY

"Well, I like to eat, sleep, drink, and be in love.
I like to work, read, learn, and understand life.
I like a pipe for a Christmas present,
or records—Bessie(1), bop, or Bach.
I guess being colored doesn't make me *not* like
the same things other folks like who are other races.
So will my page be colored that I write?
Being me, it will not be white.
But it will be
a part of you, instructor.
You are white—
yet a part of me, as I am a part of you.
That's American."

—From *Theme for English B*, 1959
Langston Hughes, African-American poet (1902–1967)

This exhibit of models of inventions and improvements made by African Americans proved popular.

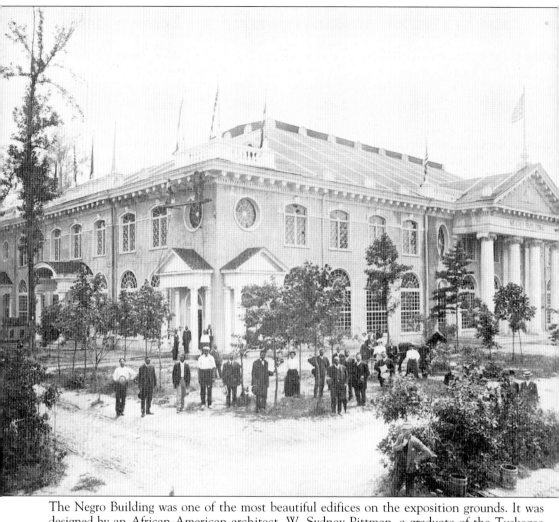

The Negro Building was one of the most beautiful edifices on the exposition grounds. It was designed by an African-American architect, W. Sydney Pittman, a graduate of the Tuskegee and Drexel Institutes, and all construction work was completed by African-American mechanics and laborers. Pittman, of Washington, D.C., became the first African American to have a design accepted by the United States government. The cornerstone of the Negro Building was laid on February 14, 1907, by the General Lodge of the Negro Masons of Virginia. Giles B. Jackson, by 1907, the director general of the Negro Development and Exposition Company, gave a stirring address. The building's contents included all products of African-American invention and industry. The exhibits showcased works in mechanical, agricultural, educational, and domestic industries, and in the religious life of African Americans in the United States. Hampton Normal Institute (later Hampton University), Virginia Union University, Howard University, and many other African-American educational institutions exhibited in the building. The Negro Building was located in the extreme western edge of the grounds and had about 5 acres of land upon which were located the buildings and shops set aside exclusively for African Americans to use. The state of North Carolina made a special appropriation for representation of its African-American people in the Negro Building and was the only state to do so. Thomas J. Calloway, Andrew F. Hillyer, and Giles B. Jackson were in charge of the operation of the Negro Building.

The Black Jamestown Exposition Company

The fact that African Americans were not included in the plans laid out by the commissioners of the Jamestown Exposition Company hardly comes as a surprise. With Jim Crow laws in full force in the United States, African Americans were forced to finance and build their own contribution to the Jamestown Exposition. The Negro Development and Exposition Company was chartered by the laws of Virginia on August 13, 1903, for the purpose of holding a separate exhibit on the occasion of the 300th anniversary of the landing of the first English-speaking people of this country at Jamestown, Virginia. Before the incorporation of this company, the commonwealth of Virginia organized and chartered the Jamestown Exposition Company, under the law of the state, for the same purpose, by holding a land and naval exhibition at or near Hampton Roads, Virginia. The Jamestown Exposition Company was offered, owned, and operated by the white people of the United States. The Negro Development and Exposition Company (hereinafter referred to as the Negro company, unless otherwise noted) was headquartered at 528 East Broad Street, Richmond, Virginia; 663 Church Street, Norfolk, Virginia; and the corner of Twelfth and U Streets, Northwest, Washington, D.C., at the True Reformers' Hall. As one of the Negro company's organizers remarked of the True Reformers' Hall, "no one can miss it." W. Isaac Johnson served as president of the African-American organization, and the Reverend A. Binga Jr., its vice president.

In order to encourage African Americans to attend the Jamestown Exposition, Johnson and Binga authorized an Address to the American Negro in 1907. This document, part of the Daniel A.P. Murray Collection, 1818–1907, in the Library of Congress, noted the following:

The Negro felt that in as much as there was to be a celebration of the said event by the white race, it would be a fit and opportune time for the Negro to come upon the scene and there present to the nations of the earth, the evidence of his thrift and progress, by putting upon exhibition the articles and things made and invented, created and produced by the race since its emancipation, and that in accordance with the uncertain and unsatisfactory conditions now existing as to the Negro in this country, that a creditable exhibit of his industrial capacities would result in untold good to the entire race, that the Negro question has been and is being discussed all over this country, some taking a favorable view of the situation, others taking different views, leaving him in an unsatisfactory position as to his relation to the government and the country in which he lives.

Great emphasis was placed on a "creditable exhibit" to show what African Americans had achieved in the course of their starring role in American history. Johnson and Binga found it inconceivable that the nations of the world had been invited by the President of the United States to participate in the Jamestown Exposition, but not African Americans, but in their optimism, both men expressed the belief that an African-American exhibit would carry untold benefits for their people.

After incorporation, the Negro Development and Exposition Company's executive officers conferred with the Jamestown Exposition Company officers and secured concessions to hold a separate and distinct exhibit on the occasion of the tercentennial exposition of the Jamestown colony's establishment. The Negro company presented its plan for a special exhibit "on account of the race to the American people regardless of race or color." Johnson and his Negro company officers first sought the endorsement of the National Negro Business League, of which Dr. Booker T. Washington was president(2). Their second effort was to secure the endorsement and support of the National Negro Baptist Convention at its session in the city of Chicago on October 27, 1905, where they were successful in garnering the conventioneers unanimous sanction. The Negro company also received the endorsement by numerous state Baptist conventions and state African Methodist Episcopalian conferences, including those in Virginia. The company's organizers appealed for appropriations from various states participating in the exposition, but Johnson ultimately had to go to President Theodore Roosevelt for

assistance. Roosevelt immediately endorsed the Negro company's request. To make his position totally clear, Roosevelt used his visit to the South in passing through Richmond, Virginia, on October 18, 1905, to solidify his pledge of support. As Roosevelt's procession moved through the city of Richmond, he stopped the cortege upon reaching the headquarters of the Negro Development and Exposition Company, and there, Roosevelt called for Giles B. Jackson, the director general of the company and, addressing Jackson, said in part: "Mr. Jackson, I congratulate you. I assure you and your people that you have my hearty support in the efforts you are making to have a creditable exhibit of the achievements of your race and I commend you in the effort you are making for the betterment of the condition(3) of your race."

With Roosevelt's endorsement, the Negro company went to Washington, D.C., to present an appropriations bill to the Congress of the United States, asking for a quarter of a million dollars to support their exhibit. The bill was sent to the Industrial Arts and Expositions Committee and after several meetings, one in the city of Norfolk and the others in Washington, the Congress agreed to appropriate $100,000. The bill was then reported by the appropriate committee in the United States Senate, and on June 30, 1906, the appropriation passed both houses of Congress and was signed by Roosevelt and henceforth into law.

It was very difficult for the Negro Development and Exposition Company to the appropriation from Congress, with opposition to their quest coming from where it was least expected. Not one congressman, save one, objected to appropriation of the money, the bill passing Congress with only one vote against (and no one knew who voted nay). Opposition to the appropriation came from African Americans who wrote letters to Congress protesting against government aid to the Negro company, and these were "men of learning."

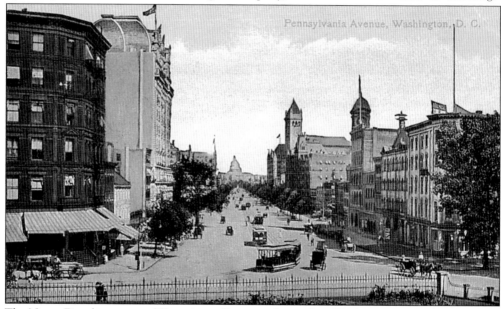

The Negro Development and Exposition Company located its Washington, D.C. headquarters at Reformers' Hall, in a city no less segregated than cities in the South. The lines of color (black and white) in the city of Washington, D.C., were clearly drawn at the turn of the century as leaders in America's seat of power maintained the status quo of race relations across the country. This Americhrome postcard image shows Pennsylvania Avenue from the United States Treasury. The avenue was, and is, the principal thoroughfare of the city. The United States Capitol and Congressional Library are visible in the distance. Note the number of streetcars and horse-drawn carts moving along Pennsylvania Avenue c. 1907. The postcard was printed in the United States for The Washington News Company, of Washington, D.C.

Government aid to African Americans participating in expositions was commonplace. The Negro department of the Atlanta Exposition, and the African-American exhibit at the Charleston Exposition were provided government money to participate in their respective expositions. In fact, the African-American exhibit from the Charleston exposition was taken by that exposition's organizers and exhibited in Paris, France. In each case of African-American participation in national and international expositions and world's fairs, and the Jamestown Exposition was certainly no exception, the companies were owned and officered by African Americans, and made and created by them, all at a time in American history when Jim Crow laws(4) reigned.

Some African Americans argued against the Jamestown Exposition exhibit because of Jim Crow car laws, prevalent throughout the South, but the Negro Development and Exposition Company, having charge of the African-American exhibit at the Hampton Roads event, made sure that black visitors would have equal and good accommodations travelling to and from the exposition. The company took up the issue with railroad companies, and, in turn, the railroads pledged to provide good, clean, and satisfactory accommodations, but did not go so far as to admit blacks into white travelling cars. The law made provisions for "separate but equal," and that meant segregated accommodations.

The Negro Development and Exposition Company issued their address so that African Americans would attend the exposition unafraid of travelling conditions and accessibility to the actual exhibits on the grounds. The company made a poignant concluding remark in their address:

The fact that there will be crowds of people coming from all over the country to the exposition will make it convenient for the reunion of families, that have been separated for ten, twenty, yes, thirty years. The opportunity will be afforded for the meeting of our friends, whom we have not seen since the war. The opportunity will be afforded for the meeting of our kin-folks and relatives, whom we have not seen since our emancipation.

1. Bessie refers to Bessie Smith, the great blues singer.
2. Washington was an advocate of accommodation of African Americans in white society. W.E.B. DuBois, Ph.D., argued for equal access to political power and education for blacks, railing against Washington for his views of African Americans' place in American culture, a culture that has been defined in the twentieth century by the color line.
3. The condition of African Americans at the turn of the century was hardly improving. Cataclysmic flooding coupled by the spread of the boll weevil created further economic and social misery for blacks and whites in the rural South. The agricultural depression led to a higher-than-usual poverty rate in the black population. Even though black men had won the right to vote as early as 1867, whites in the South imposed literacy tests and poll taxes to exclude them from garnering political positions of power. White southern leadership even went so far as to add a grandfather clause to their state constitutions, which stated that persons who could vote on or before January 1, 1867, or whose father or grandfather could vote, would not be subjected to taking the literacy test or paying the poll tax. While this paved the way for whites to vote, it clearly excluded blacks from voting.
4. Jim Crow laws were named for Thomas Dartmouth Rice, a white entertainer who was popular in the 1830s for his black-face routine and a patronizing song he performed called "Jim Crow." For whites, especially in the South, the name was synonymous with a racist image they conjured of foolish and ineffectual blacks. By the time the Jamestown Exposition was being planned and executed in Hampton Roads, African Americans were fully entrenched in their efforts to overcome Jim Crow, a common term in the South for segregation.

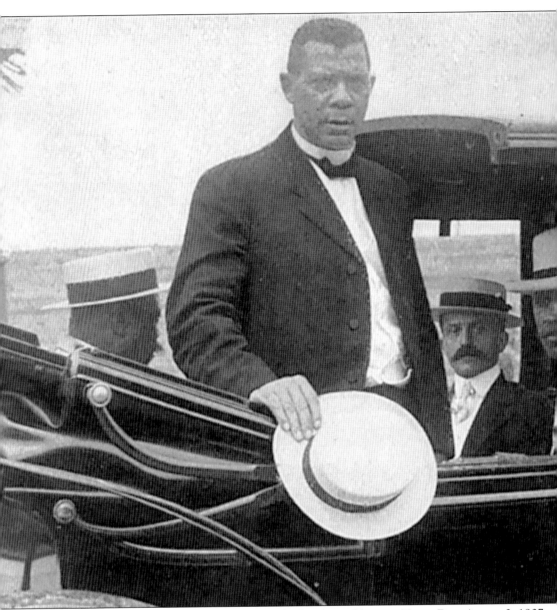

Booker T. Washington was on hand to give the keynote address on Negro Day, August 3, 1907. Considered the leading African-American educator of his day, Washington praised the work accomplished by African Americans at the exposition. He said, in part, "I believe that our people should take advantage of every opportunity no matter where presented, North or South, to show to the world the progress that we as a race are making."

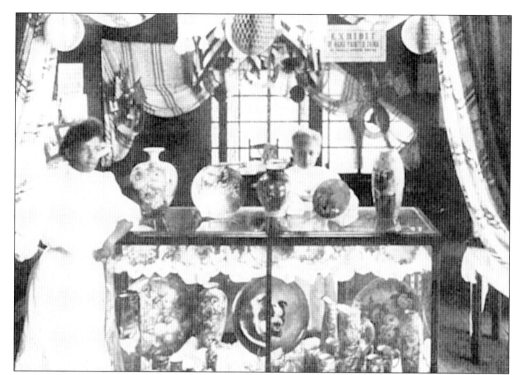

Frances Spencer Dorkins, of Norfolk, Virginia, exhibited her China painting and fancy work in a show of 40 of her best pieces, all of which were impressive. Her designs were original and all the colors fired by Dorkins. Three large plaques, one of which carried a dog's head painted from life, and two floral pieces won gold medals. Dorkins is standing to the left in the photograph, taken by a Jamestown Official Photograph Company photographer during the exposition.

Ida Underwood, of Rainbow, Connecticut, won an award for her embroidery. Though she was unable to travel to the exposition, like so many of the African-American artisans showing work in the Negro Building, Underwood's embroidery won event awards. One of her best pieces, a lace centerpiece, is shown here.

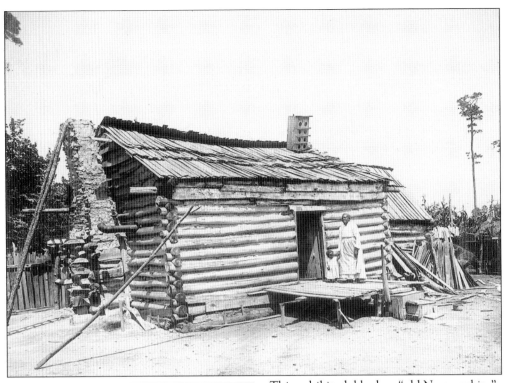

This exhibit, dubbed an "old Negro cabin," was included in the African-American displays on the exposition grounds.

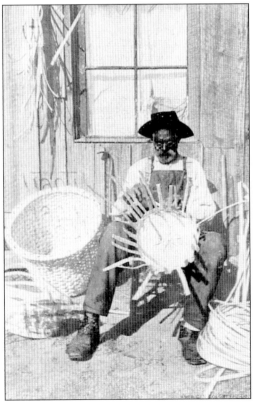

Outside an outbuilding of the "old Negro cabin," this elderly basketmaker wove beautiful baskets. The postcard, No. 156 in the Jamestown Amusement & Vending Company's series, was an official souvenir of the exposition and one of the few to depict African Americans.

Three
WOMEN AND CHILDREN

"Infancy's the tender fountain,
　Power may with beauty flow,
Mother's first to guide the streamlets,
　From them souls unresting grow—

Grow on for the good or evil,
　Sunshine streamed or evil hurled;
For the hand that rocks the cradle
　Is the hand that rules the world."

—From *The Hand That Rocks the Cradle Is the Hand That Rules the World*, 1865
William Ross Wallace, American lawyer-turned-poet (1819–1881)

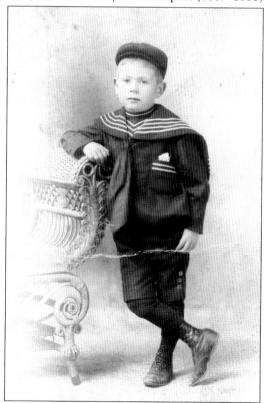

The little fellow in this image, c. 1907, was wearing clothing indicative of his times. The sailor's uniform and military uniforms, in general, were produced in children's attire. There are many images from the Jamestown Exposition that show children wearing this dress.

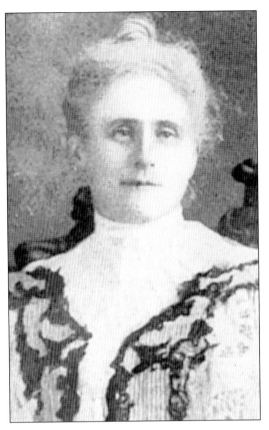

When the Jamestown Exposition board of governors (all men) received requests from women's organizations wishing to be represented on the grounds, most of these groups were philanthropic in nature. An exhibition category titled "Women's Philanthropic Work" was established, and women's participation was then modeled after the experiences of organizers at the St. Louis Exposition. St. Louis organizers controlled the building, and each women's organization was given charge of its own rooms. Kate Waller Barrett, general superintendent of the Florence Crittenden Mission, negotiated the arrangement on behalf of women's organizations. The Woman's Building included Barrett's mission, the Women's Christian Temperance Union, and the National Council of Women. Each organization furnished and occupied two rooms on the second floor of the building. Barrett had a great deal of experience with other expositions, but it was while in Norfolk attending the Jamestown Exposition that she decided to make her home in the city. Kate Waller Barrett is shown here as she appeared about 1906.

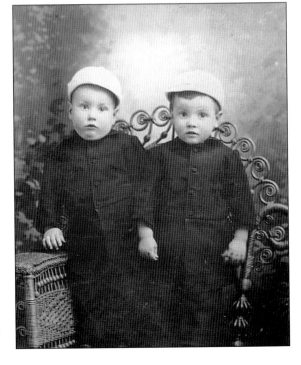

The twin boys shown here were approximately two years of age when this photograph was taken of them standing in a wicker chair, a common prop used by early photographers taking pictures of small children. Pictures such as this one were common souvenirs at the Jamestown Exposition and were often made into postcards that were mailed from the exposition with a special event postmark. This photograph was acquired in Norfolk, where it was taken c. 1907 at the exposition.

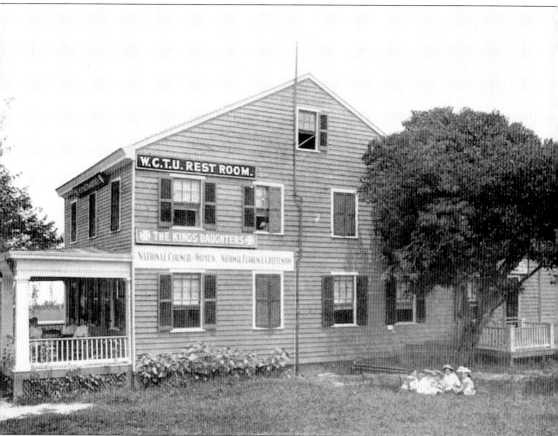

The Woman's Building conducted numerous good works while the exposition was open. A number of young women were provided financial assistance in hard times, and one was actually boarded at the Woman's Building for two months, while many others were helped with problems that had more immediate solutions. Girls separated from their friends at the exposition were given lodging overnight and reunited with their parties the next day. Charles N. Crittenden, president of Barrett's mission, and John Huyler, of New York, gave generous donations to the work of women at the Jamestown Exposition. The King's Daughters of Virginia also maintained two rooms on the second floor of the building, but King's Daughters did not arrive at the exposition until October, one month before the event ended. The photograph shown here was taken in October, after King's Daughters opened its rooms. Notice the lovely group of little children in the right foreground.

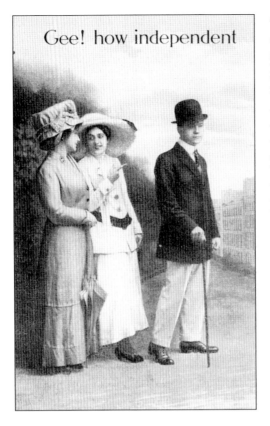

Gee! how independent

The Jamestown Exposition became an early trial-ground for woman suffrage, though nothing earth-shattering occurred. The National Council of Women had its headquarters in the drawing room of the Woman's Building. The National Council was composed of the most important women's societies in the United States and was affiliated with the International Council of Women. The Norfolk Council of Jewish Women worked closely with the National Council during its time at the exposition, providing additional hostesses for the house. This postcard, produced in the period, makes an oxymoron of male independence.

The YWCA and the Travelers' Aid Society established restrooms on the grounds (shown here in an exposition photograph) and a concession in their own building located at the northeast corner of the parade ground. The YWCA Restaurant was operated successfully from this building.

The Mothers' and Children's Building (above) and the Pocahontas Hospital (below) provided for the ills that were sure to overtake the great numbers of people who congregated at the exposition. Pocahontas Hospital was located at the east border of Lee Parade, opposite the States' Exhibit Palace. The Mothers' and Children's Building, as its name implied, was a place for women and children to rest, facing Hampton Roads, on Willoughby Boulevard, near the Inside Inn. The Mothers' and Children's Building was completed at the behest of the National Congress of Mothers, headed by Mrs. Frederick Schoff, national president. The National Congress was invited to take charge of the building in August of 1906, which was accepted. Schoff used the building as a place to promote better care of children. The day nursery, kindergarten, and library housed in the building were intended to spread a broader message about children's quality of life. The Jamestown Exposition was the first to permit the National Congress to direct its own efforts at an exposition or world's fair, thus allowing the women's organization to send a clear message regarding the home and aid to children. It was the first exposition to recognize the importance of women's and children's issues.

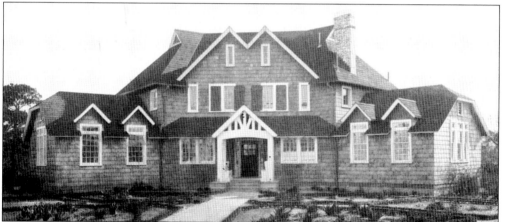

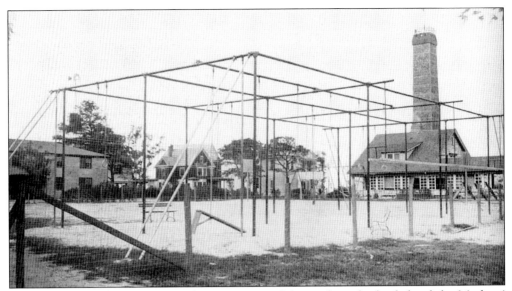

The children's playground, shown here, was part of the working display behind the Mothers' and Children's Building. The Playground Association of America maintained the playground, providing literature to thousands of mothers pertaining to newer and safer equipment. The area was equipped with swings and athletic devices by A.G. Spalding & Brother and the Narragansett Machine Company, while W.S. Tothill, of Chicago, contributed the slide. The association also provided an exhibit in the Palace of Social Economy.

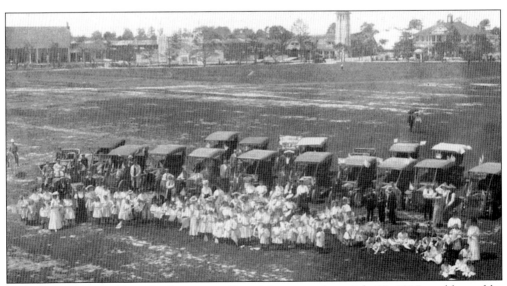

Orphan's Day was held on the Jamestown Exposition grounds on July 17, 1907, and hosted by the Tidewater Automobile Club. The orphans of Norfolk attending the day's events came from the St. Mary's Orphan Asylum, the Norfolk Female Orphan Asylum, the Boys' Home, and the Society for the Prevention of Cruelty to Children. Members of the automobile club drove the children to the exposition in their motor cars, indulging the little ones to a day of fun in the concessions of the War Path and the Miller Brothers' 101 Ranch show. The National Council of Mothers provided the children's lunch.

There is no doubt that one of the most charming finds in the process of orchestrating these volumes was the disclosure of academic works perpetuated by children and exhibited at the exposition in the Education Building. The Department of Public Instruction of the State of Virginia made a wonderful exhibit from the primary and secondary schools around the commonwealth. Sixty counties and ten cities were represented in the display, which was planned to include five classifications: the Progress and Trend of Educational Life in Virginia; the Concentration of School Work on Environment; the Concentration of School Work on Local History; the Efficiency of Work; and the Grading of Courses of Study. The work of Virginia's schoolchildren was shown by grades and arranged very artistically by municipality. Schools from other states also participated. The story below, simply titled "Bob" (see the picture of Bob, the dog), was, unfortunately, not signed by its author, a young boy just starting high school in Hampton.

"Bob"

Bob licked his plate regretfully, gave a disdainful sniff at a bit of potato, and started for the library. Making a wide detour of the house cat which lay before the fire washing her paws; he climbed into a large rocking-chair and settled himself cozily. It was lonely when the family was away, but Bob had learned to look on the bright side of life; besides it was not often that he was permitted to lie in the big rocking-chair and the hearth-rug is a dangerous place for one's toes may be stepped on at any moment.

An hour later he awoke with a start from a delightful dream of a squirrel that could not climb a tree. Someone was trying to unlock the front door. Bob was pleasantly surprised, he had not expected his master and mistress to come home so early. The door opened and a roughly dressed man entered the hall. Bob trotted to the library door and wagged his tail, tentatively.

'Good doggy, good doggy,' called the man softly, but Bob did not stir. The man stepped to the umbrella-rack.

'Grr-er-r,' growled Bob. The man put his hand on a gold-handled umbrella. With a sharp bark Bob darted across the room to be met with a clumsy kick. Like a little black-and-white fury he seized the man's leg, shut his eyes and hung on. The man struggled frantically, striking the dog with his fist.

'That will do, Bill,' a voice called, and Policeman McCarty stood in the doorway with Mary, the cook, looking over his shoulder. 'I have my pistol with me, Bill, now hold out your hands while Mary puts the handcuffs on you. 'Tis a long and weary time I have had looking for you and 'tis meself that's glad to find you.'

'There, there,' he said to Bob who was worrying the man's trousers, 'there's no need for that now. Come, Bill! I'll be back from the station in less than half an hour, Mary, me darlint,' he added as he closed the door.

Bob sniffed about the hall, licked a sore foot, and curled up in the rocking-chair, little dreaming that he was a hero. (Courtesy of the City of Hampton.)

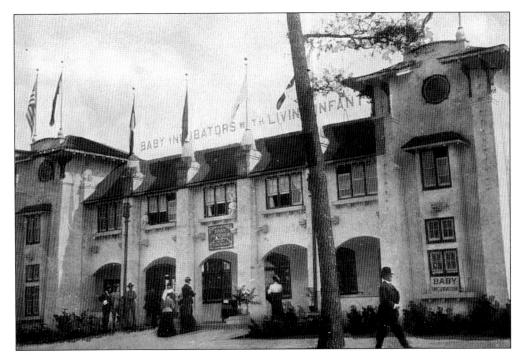

Baby Incubators with Living Infants

The Baby Incubators with Living Infants (shown above) was billed as "a triumph of medical science." The actual incubator was described as air tight except for the ventilating pipe, which passed over hot pipes in the floor and circulated warm air over the baby. An exhaust vent carried off impure air. Dubbed "the artificial mother," exhibition planners noted that many babies had been saved with the aid of the incubator. In reality, the story of the incubator "hospital" at the Jamestown Exposition was more complicated. The baby incubator hospital was the contrivance of Dr. Martin Arthur Couney, a physician who was born in France in 1870, and who studied medicine in Germany, before going back to Paris in the 1890s to do his post-graduate work with world-renowned pediatrician Dr. Pierre Budin. Budin had been experimenting for a number of years with new ways to treat premature infants. Budin's early successes with baby incubators came on the heels of his study with Dr. Etienne Stephane Tarnier, the first pediatrician to experiment with incubators. Budin improved on Tarnier's design and infant care protocol. Budin persuaded his talented student to partner with him on the exhibition circuit (though he and Budin would eventually go their own ways), taking the premature infant incubator on the road. Couney first exhibited six of his incubators at the Berlin Exposition of 1896, and the premature infants used in the exhibit were gleened from Berlin's Charity Hospital.

Couney took his incubator sideshow on a successful tour of the world's finest expositions and world's fairs, ultimately arriving in America for the Trans-Mississippi Exposition in Omaha, Nebraska, in 1898. The infants used in his Omaha exhibit came from families looking for their last shred of hope in Couney's incubator contraption. Fragile infants from otherwise well-to-do families rested in incubators beside fragile infants from Omaha orphanages, but many of the tiny babies improved dramatically under Couney's care.

Couney was plagued by a doubting-but-curious public, voyeurs of sorts who associated incubators with chickens, not human babies, but who could not resist the urge to tour one of the pediatrician's exhibition hospitals. One might wonder why the good doctor opted to take

his design, one of the first successful mechanical baby incubators, on the sideshow circuit. The answer was clearly funding. Couney had been unable to garner funding of his incubator design through legitimate medical societies, so the tenacious doctor financed his work giving demonstrations at world's fairs. Couney's exhibit, a hospital-turned-sideshow, may have had the American public up-in-arms, but the American Medical Association endorsed Couney's medical protocol for treatment of premature babies and his incubator equipment. The late nineteenth and early twentieth centuries demonstrated particularly high rates of premature infant mortality, in large measure because hospitals were not equipped to care for them properly. Couney's incubator was state-of-the-art, and the American Medical Association recognized that Couney was saving lives, even if his method of research and development funding was unorthodox.

The incubator designed by Couney had an electric motor, which pulled in outside air through three filters, then into a glass-and-steel incubator. The incubator had a small chimney with a suction fan to conduct impure air out of the case containing the premature infant. Babies received oxygen through a tube, and wet nurses provided the milk.

Tours of Couney's Baby Incubators with Living Infants left Jamestown Exposition crowds in awe of his invention. It is unfortunate that the Jamestown Exposition lasted less than one year, because some of Couney's amusement park and world's fair incubator hospitals remained in operation for several years. The result of Couney's efforts to exhibit in grandiose public forums set the course for future medical treatment of premature infants across the United States, and the world.

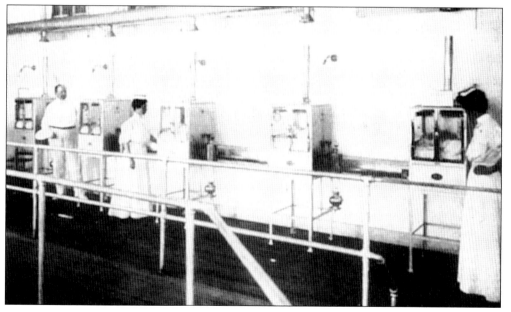

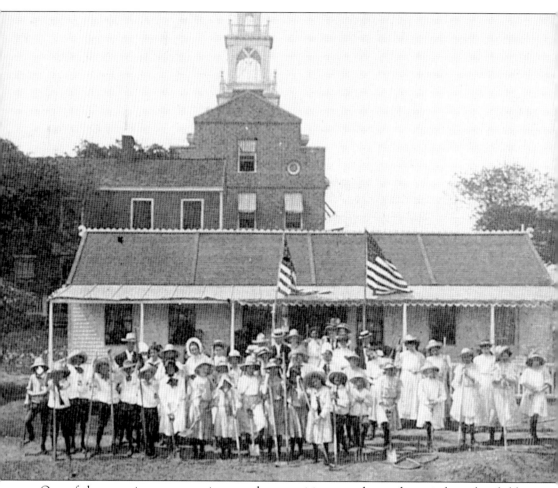

One of the most important projects at the exposition was the work carried out by children under the auspices of a New York group organized to promote children's welfare. A Children's School Farm was opened on the Jamestown Exposition grounds on June 22, modeled after the first Children's School Farm begun in New York in 1902 by the wife of Henry Parsons. Mrs. Parsons had secured permission from the New York City park commissioner the right to use part of vacant lots at 54th Street and Eleventh Avenue to start a farm. When New York City authorities planned the DeWitt Clinton Park for the site occupied by the farm, they were so impressed by what they had seen in Parsons's work with the children, officials integrated it into part of the new park's plans. To plan and furnish similar farms for other communities, Parsons and her staff formed the International Children's School Farm League in 1907.

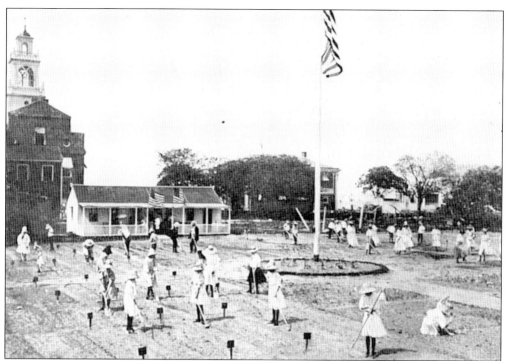

The Children's School Farm planned for the exposition was installed and directed by Parsons's son, Henry Griscom Parsons. A small house and barn were built and equipped on a plot of land lying to the north of the Social Economy Building. The farm encompassed roughly 1 acre. Here, children attended classes teaching them how to plant and cultivate garden vegetables and flowers. The young girls in this photograph are getting a lesson in hoeing. This farm proved exceedingly interesting to the children, and organizers were reportedly pleased that this learning experience provided young people adequate knowledge and practical farming exposure. The Massachusetts Building is the towered structure looming in the background of this image.

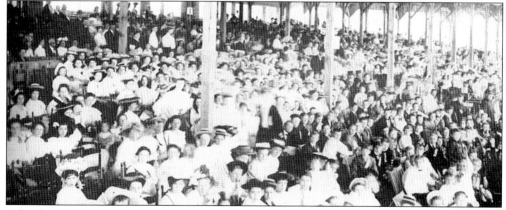

Schoolchildren were brought to the exposition on Tidewater Day, June 7, for reduced fees that cost them 10¢ to ride transportation to the exposition, and 10¢ admission. The first event of the day was a parade of the schoolchildren representing Norfolk, Portsmouth, Norfolk County, Newport News, and Hampton. The children, pictured here in the grandstand, appear very happy to be part of the events of the day.

This was the Department of Public Instruction of the State of Virginia's exhibit, featuring the work of schoolchildren from throughout the commonwealth.

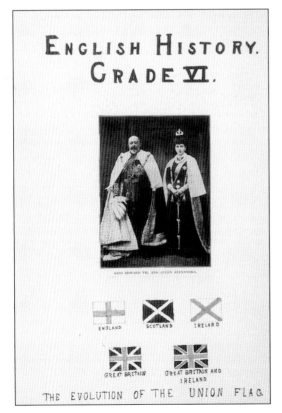

A sixth-grade Hampton student fashioned this introduction to English history for one of the books submitted by the school system for exhibit. The photograph shows King Edward VII and Queen Alexandria in all their regalia. King Edward VII was a popular visitor to the exposition.

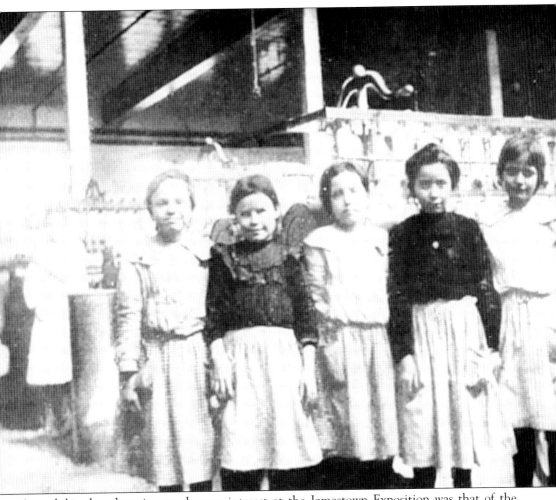

An exhibit that drew intense human interest at the Jamestown Exposition was that of the National Child Labor Committee, headquartered in New York. Dr. A.J. McKelway, secretary for the Southern states, and Marie Hunter, a graduate of Vassar College and expert in the trials and tribulations of child labor violations, were in charge of the National Child Labor Committee exhibit. Across one side of the room occupied by the committee in the Palace of Social Economy was written the words of John Ruskin: "It is a shame for a nation to make its young girls weary." On another wall was the phrase: "Childhood is the period for education and play, not for labor." Among the large photographs hung on the walls, noting the state of child labor in different states, was this simple, yet powerful picture showing five little girls standing beside a spinning frame, which reached above their heads and bore the legend, "They can earn forty cents in a ten-hour day, but they cannot read." There were also photographs of New York City sweatshops, and a photograph of little children in a Southern cotton mill mending broken threads.

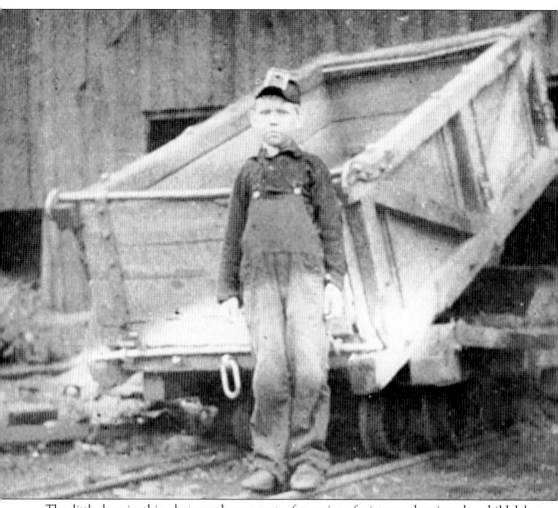

The little boy in this photograph was part of a series of pictures showing the child labor atrocities committed by the coal industry. He was called "an old man at 12 who could neither read or write." There were some in attendance at the Jamestown Exposition who called this photograph the most compelling they had ever seen.

Four

AMERICAN IMPERIALISM ON PARADE

"It was a time of great and exalting excitement. The country was up in arms, the war was on, in every breast burned the holy fire of patriotism; the drums were beating, the bands playing, the toy pistols popping, the bunched firecrackers hissing and spluttering; on every hand and far down the receding and fading spread of roofs and balconies a fluttering wilderness of flags flashed in the sun; daily the young volunteers marched down the wide avenue gay and fine in their new uniforms, the proud fathers and mothers and sisters and sweethearts cheering them with voices choked with happy emotion as they swung by; nightly the packed mass meetings listened, panting, to patriot oratory which stirred the deepest deeps of their hearts, and which they interrupted at briefest intervals with cyclones of applause."

—From *The War Prayer*, dictated in 1904 or 1905
Mark Twain (1835–1910)

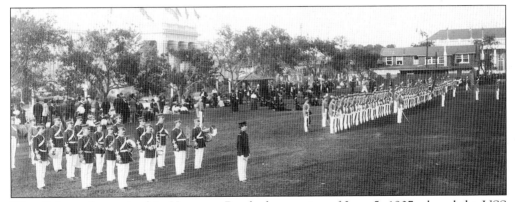

West Point cadets arrived in Hampton Roads the evening of June 5, 1907, aboard the USS *Sumner*, debarked immediately and proceeded to set up their camp, which the commandant had appropriately named Robert E. Lee. The United States Military Academy's cadets were the star attraction of the parade field, performing their famous "Monkey Drill" to the delight of thousands of onlookers at Lee Parade Ground. The photograph shown here was taken on Georgia Day, June 10. The cadet corps of West Point, joined by those of Virginia Polytechnic Institute and State University and the Pennsylvania Military College, marched to Discovery Landing the morning of June 10, and there received President Theodore Roosevelt and his party, after which they participated in the parade and review of land forces. The West Point cadets completed their day with a riding drill, evening parade, dinner, tattoo, and taps. The cadet corps returned to West Point on June 11. The cadets were accompanied on their trip to Hampton Roads by Lieutenant Colonel R.L. Howze, commandant of the cadets, and numerous other officers from West Point.

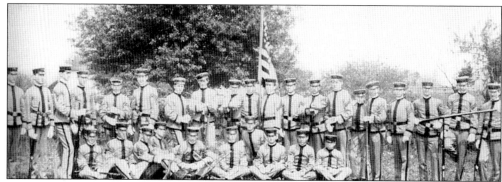

Cadets from Fork Union Military Academy, Fork Union, Virginia, arrived at the exposition on May 23 and remained for a week. The cadets were supervised by their headmaster, L.H. Walton; Lieutenant E.H. Poindexter; several of the school's trustees; and some of the teachers and friends of Virginia's premier military preparatory school. Dr. William E. Hatcher, then president of Fork Union, accompanied the boys on the trip to Norfolk.

The artillery parades executed on the parade ground were popular subjects on postcards published during the exposition. This one was mailed on November 4, 1907, about three weeks before the event ended. The quality of the image shown here, without the writing, is due in large measure to the fact that the postcard was printed in Germany for the Postal Card Company, of New York.

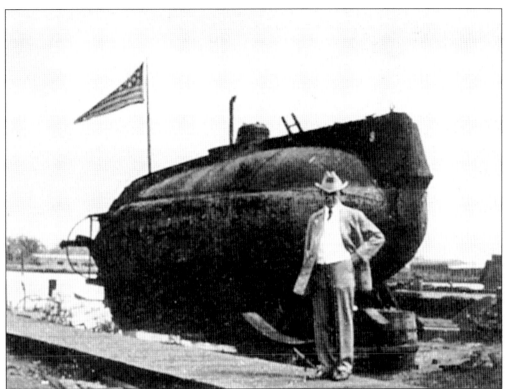

The submarine boat, *Holland*, was privately built at Crescent Shipyards, Elizabeth, New Jersey, and launched in 1898. This was the first submarine with the power to run underwater for any appreciable distance. The *Holland* was designed by John Philip Holland, an Irishman born in Liscanor, County Clare, on February 29, 1840, and the man who developed the first real submarine accepted by the United States Navy. The *Holland* was bought by the Navy after rigorous tests and commissioned October 12, 1900, in Newport, Rhode Island, with Lieutenant Harry H. Caldwell in command of what was likely the most unique vessel in the United States Navy at that time. In addition to Caldwell, the only officer aboard, there were five enlisted crewmen. The Navy ordered six additional unarmored submarine boats from Holland, who had already spent 57 of his 74 years studying and working on submersibles. The *Holland* was invaluable to the Navy as an experimental platform to study future submarine design. She made an interesting 166-mile surface run from Annapolis, Maryland, to Norfolk, Virginia, between January 8–10, 1901, providing useful information on her performance parameters over several days' time. The *Holland* would not return to Norfolk again until after July 17, 1905, when she detached as a training vessel for cadets at Naval Torpedo Station, Newport, Rhode Island, and arrived to finish out her service to the Navy at Naval Station Norfolk. The Navy's first true submarine was struck from the Navy Register of Ships on November 21, 1910, and sold for scrap. John Philip Holland, shown here with his submarine boat at the Jamestown Exposition, died on August 12, 1914, in Newark, New Jersey.

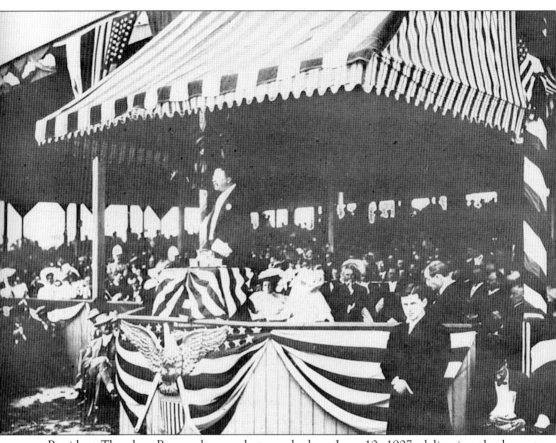

President Theodore Roosevelt was photographed on June 10, 1907, delivering the keynote address for Georgia Day. He had arrived early in the morning aboard the presidential yacht *Mayflower*. In his address, Roosevelt remarked, "His colony [Georgia] welcomed alike those who fled from political or social tyranny, and those, whether Christian or Jew, who sought liberty for conscience's sake. It was a high and honorable beginning; and I am proud, indeed, of my Georgian ancestry, and of the fact that my grandfather's grandfather, Archibald Bulloch, was the first governor, or as the title then went, President of the new State, when the Continental Congress, of which he was also a member, declared that the Thirteen States had become a new and independent nation." Roosevelt's speech held to form as the President continued to address issues of social class and ethnicity, and the troubling subject of "labor leaders": "We ought not to tolerate wrong. It is a sign of weakness to do so, and in its ultimate effects weakness is often quite as bad as wickedness. But in putting a stop to the wrong we should, so far as possible, avoid getting into an attitude of vindictive hatred toward the wrong-doer." One of his most engaging passages of the speech came toward its end. Roosevelt opted late in the speech to focus the audience's attention on world affairs and military power. He stated, "Modern wars are in reality decided long before they are fought. I earnestly hope that we shall never have another war; but if we do, its result will have been determined in advance; for its outcome will mainly depend upon the preparation which has been made to meet it in time of peace." The exposition itself epitomized the military preparedness of which Roosevelt spoke as impressive legions of American soldiers and sailors paraded for the president before and after his speech, and the Great White Fleet gathered in Hampton Roads to pay homage to American imperialism.

The parade planned for Georgia day, later scheduled to pass the grandstand and President Theodore Roosevelt, met at this staging area.

Reviewing the parade on Georgia Day was probably among the most exciting events for exposition patrons. The show of prominent military figures, public personalities, foreign dignitaries, and royal visitors entranced the public.

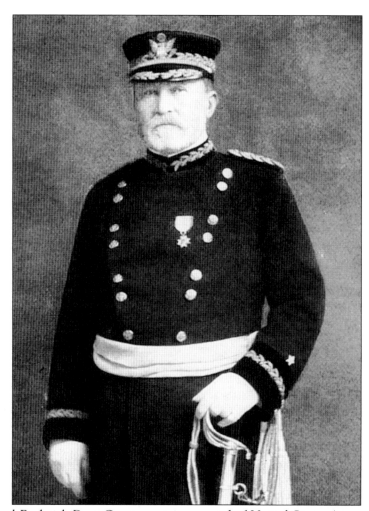

Major General Frederick Dent Grant was in command of United States Army troops at the Jamestown Exposition. At the time of the exposition, Grant was in charge of the Army's Department of the East, and during the actual event in Hampton Roads, he had the 23rd Infantry, Battery D; 3rd Field Artillery; and the Second Squadron, 12th Cavalry, permanently under his command. Frederick was born on May 30, 1850, in St. Louis, Missouri, to Julia Boggs Dent Grant and Ulysses S. Grant, 18th President of the United States and "Hero of Appomattox." Frederick was the eldest of four Grant offspring, all of whom not only survived to adulthood but lived long lives. He went with his father on many of his campaigns in the Civil War, and ultimately graduated from the United States Military Academy at West Point, New York, in 1871. Three years later he married Ida Marie Honore and they had two children: Princess Julia Grant Cantacuzene, who married a Russian prince, and Ulysses S. Grant III. From 1890 to 1893, Frederick Grant was the American minister to Austria-Hungary. He served as a New York City police commissioner from 1895 to 1897, but he eventually served as a major general in the United States Army, fighting in the Spanish-American War. Major General Grant died in New York City on April 11, 1912, and is buried with his wife at West Point Cemetery in New York. It is interesting to note that Frederick's brother, Ulysses S. Grant Jr., had a son he named Ulysses S. Grant IV. Also of interest is the fact that President Ulysses S. Grant, and thereby his son, derived a royal descent from David I, King of Scots, and was related to Presidents Grover Cleveland and Franklin Delano Roosevelt.

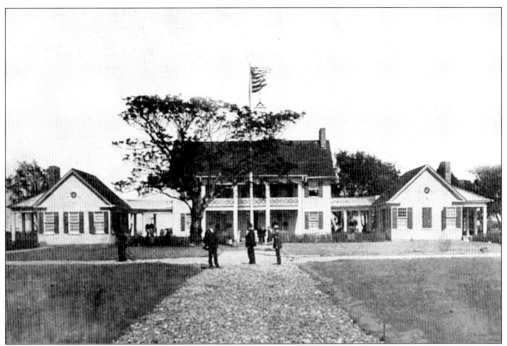

The Army-Navy Officers' Club was located on the east end of Commonwealth Avenue near New York and several of the other state buildings.

The interior of the Army-Navy Officers' Club was photographed by Harry C. Mann during the exposition.

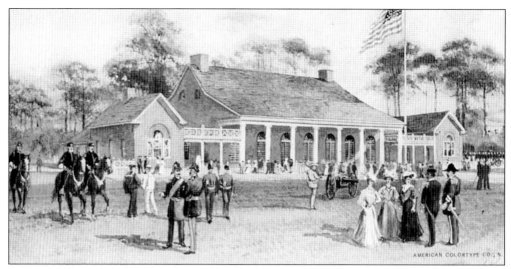

The Soldiers' and Sailors' Club for enlisted military men was near the Miller Brothers 101 Ranch at the west end of Commonwealth Avenue. The Soldiers' and Sailors' Club, pictured here in an artist's rendering on a postcard published by the American Colortype Company, of New York, for the Jamestown Amusement & Vending Company, was No. 115 in the company's exposition postcard series. The United States government erected the club as a rendezvous point for soldiers and sailors of the United States Army and Navy and foreign armies and navies visiting the exposition. (Courtesy of the City of Hampton.)

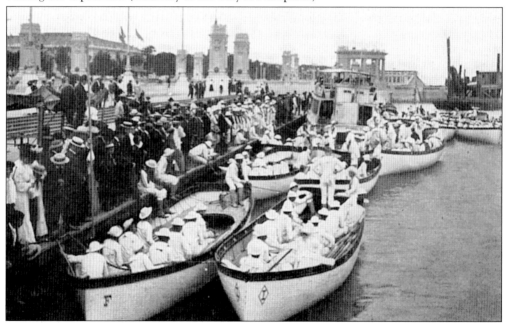

The foot of Raleigh Court was the location where steamers and other watercraft embarked and disembarked passengers from Old Point, Newport News, Norfolk, and other surrounding points. Here, launches and other boats plied the waters of Hampton Roads for hire, enabling visitors an opportunity to see the exposition by daylight or at night when the electrical lights outlining the buildings were turned on. "Jackies" from warships anchored off the exposition grounds were nearly always coming and going from the pier (shown here).

The First Kentucky Infantry (shown here in the replica Booneville Fort) arrived at the exposition on July 1 and remained through July 8. Besides daily parades, the regiment participated in a review of troops held in honor of West Virginia Day, July 2, and marched in the Fourth of July parade. The First Kentucky also gave dress parades on July 6 and July 8, and even took part in a staged battle on the Fourth of July, the heat almost impossible to bear for many exposition patrons. The regiment came to Norfolk with 508 officers and men under the command of Colonel William B. Haldeman.

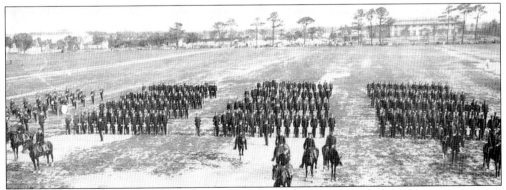

The Twenty-third Regiment of the United States Army, an infantry unit, was stationed at the Jamestown Exposition for nearly a year. The unit executed precision drills on Lee's Parade, where this picture was taken, entertaining thousands of visitors. Colonel Philip Reade was the Twenty-Third's commanding officer.

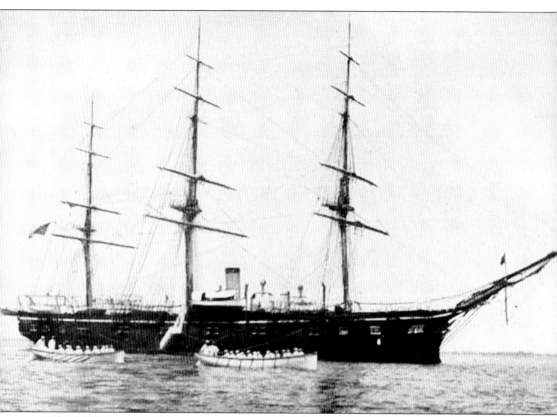

The USS *Lancaster* (shown here) was a rebuilt steam frigate constructed in Philadelphia, Pennsylvania, in 1858. The *Lancaster* was first assigned to the Pacific Station, where the frigate served as flagship during the American Civil War. Between 1879 and 1880, the *Lancaster* was rebuilt at Portsmouth, New Hampshire, and shortly thereafter, John Haley Bellamy, known as one of the United States' best woodcarvers, built the eagle figurehead for her in 1880 and 1881. The figurehead is vaguely visible in this picture. After refurbishment at Portsmouth, the *Lancaster* was sent overseas as the European Station flagship. During the Spanish-American War, the *Lancaster* was stationed at Key West, where she was Admiral Remey's flagship.

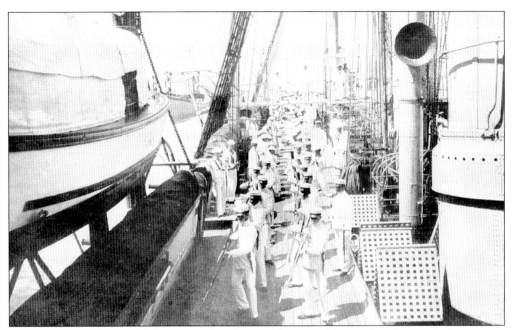

By the time the photograph here was taken by an unknown photographer during the Jamestown Exposition, the *Lancaster* was being used by the naval militia as a training ship with a crew capacity of 433 men. In this picture, recruits conduct a bayonet drill. The *Lancaster* displaced at 3,250 tons and could get up to 9.6 knots.

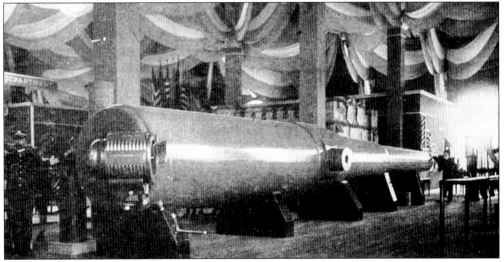

The War Department was responsible for the comprehensive military exhibits seen by visitors to the exposition. The department's ordnance branch displayed artillery, small arms, and munitions of war used by the United States Army and militia. The full-sized model of a 16-inch breech-loading rifle was displayed in the Government Building, beside which stood a 2,400-pound, cast-iron projectile, the shot used for the gun, and a 640-pound charge of smokeless powder, the quantity of explosive needed to propel the shell. This great gun was used during the Spanish-American War. The ordnance branch also had models of 12-inch breech-loading rifles with a disappearing carriage and a barbette carriage, and a 6-inch rapid firing gun mounted on a barbette carriage.

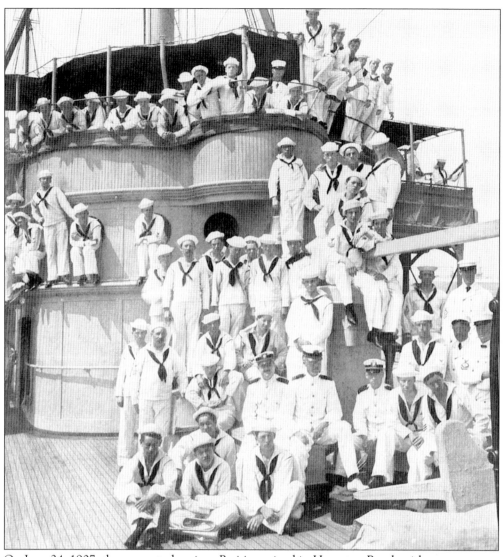

On June 24, 1907, the converted cruiser, *Prairie*, arrived in Hampton Roads with one company of the Georgia Naval Reserves, 65 men and 5 officers. Captain Joseph Dunn, of the United States Navy, was their commanding officer.

Five

MAGNIFICENT STATE BUILDINGS

"Things men have made with wakened hands, and put soft life into
are awake through years with transferred touch, and go on glowing
for long years.
And for this reason, some old things are lovely
warm still with the life of forgotten men who made them."

—From *Things Men Have Made*, 1929
David Herbert Lawrence, English poet (1885–1930)

The Georgia Building, found on Willoughby Boulevard near the western limit of Shore Boulevard, had an excellent view of Hampton Roads. The building was the only structure on the grounds devoted to a president of the United States, and Georgia Day was one of the greatest events to take place during the whole exposition. Modeled after the birthplace of Martha Bulloch, mother of President Theodore Roosevelt, the house was a splendid example of a stately old Colonial-period mansion. Martha Bulloch was married in the mansion in Roswell, Georgia. One of her brothers, James Dunwoody Bulloch, was for ten years an officer in the United States Navy before joining the Confederate States Navy. He supervised the building of the CSS *Alabama*, an ironclad, in Liverpool, England. Another of Martha's brothers, Irvine, was said to have fired the *Alabama*'s last gun. President Roosevelt made the dedication speech for the building when it was opened. The cities of Atlanta, Savannah, Augusta, Columbus, Valdosta, Macon, Rome, and Statesboro each furnished one of the 12 rooms in the house. The Georgia Building was owned and occupied by a private citizen after the exposition. It is located today in its original location on Dillingham Boulevard, formerly Willoughby Boulevard. The governor of Georgia at the time of the Jamestown Exposition was Joseph M. Terrell.

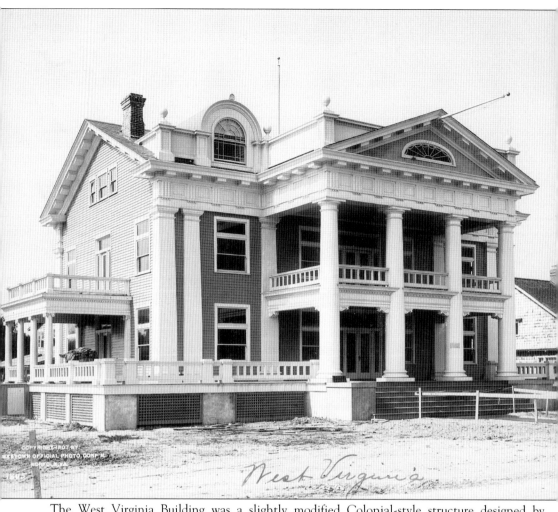

The West Virginia Building was a slightly modified Colonial-style structure designed by Rabenstein & Warne, and the builders were H.P. Withrow & Company, both of Charleston, West Virginia. The governor of West Virginia at the time of the exposition was William Mercer Owens Dawson, chief executive of the "Little Mountain State" from 1905 to 1909. The governor appointed United States Senator Stephen B. Elkins as president of the West Virginia Commission, representing the state's citizens in Hampton Roads. After purchasing the building in 1917, the Navy used it as quarters. In 1942, additional quarters were desperately needed, leading to construction of a brick wall through the center of the house. With the addition of a kitchen wing, the house was opened as two quarters. Each quarter has five bedrooms. The building, now known as West Virginia House, sits on Dillingham, formerly Willoughby Boulevard, in its original location. Willoughby Boulevard was renamed in honor of Rear Admiral Albert C. Dillingham, who was given the responsibility of converting the former Jamestown Exposition site into what became Naval Operating Base Norfolk. Work on the large Sewell's Point tract, covering roughly 474 acres, began on July 4, 1917, the day the Navy assumed ownership of the property. The naval base was later commissioned on October 12, 1917.

The West Virginia Coal Tower was a striking column located on Willoughby Boulevard near the West Virginia statehouse, situated in the western portion of the grounds. The tower was 123 feet high and 16 feet square at the base, 12 feet 6 inches at the top. It was built to represent the average thickness of 19 seams of coal mined commercially in West Virginia.

To lend some perspective, these are a few of the state buildings on Willoughby Boulevard, a road that originally stretched several miles along Hampton Roads' shores. This view shows a portion of the structures west of Government Pier and Raleigh Court. The building to the left is the Pennsylvania Building, next is the Virginia Building, and Maryland and Missouri Buildings, in that order. Along the boardwalk (foreground) was a continuous flow of visitors observing the buildings and the activities taking place on the waters of the Roads.

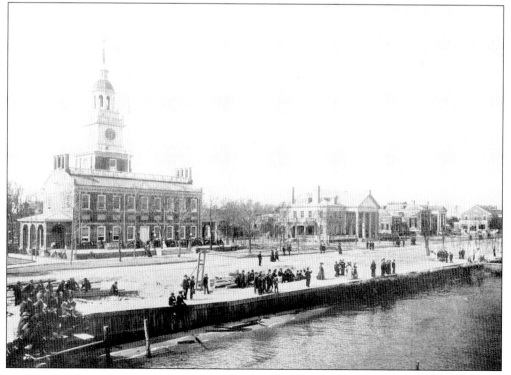

The Ohio Building was a faithful reproduction of Adena, a stone house that stands just beyond the limits of Chillieothe in Ross County, Ohio. Adena was built by Thomas Worthington, the first United States senator from the new Ohio Territory, and it was in 1799, while serving in the upper house of Congress, that he laid the foundations of the house. The original Adena was designed by Benjamin Latrobe. The exposition Adena was built by the Hanley-Casey Company of Chicago and Norfolk. After the exposition, the house was in private ownership. The Navy acquired the property in 1917. By construction of a wall down the middle of the house, the Navy made two quarters out of the house. The Ohio governor who set the state's participation in the Jamestown Exposition in motion, John M. Pattison, died shortly after his election to office, expiring on June 18, 1906. He was succeeded by Andrew Lintner Harris, who remained Ohio's governor from 1906 to 1909.

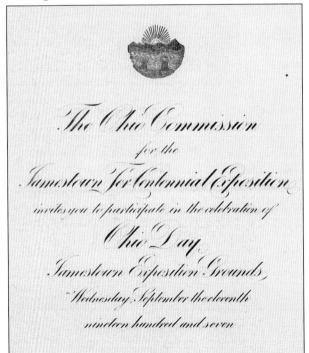

The Ohio Commission for the Jamestown Tercentennial Exposition invited company to participate in the celebration of Ohio Day, Wednesday, September 11, 1907.

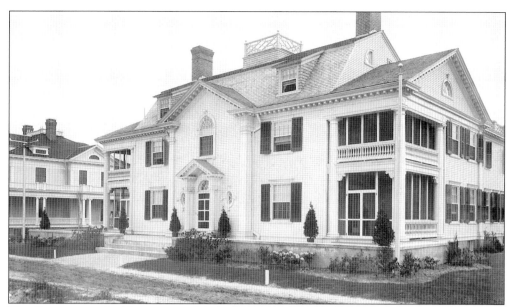

The Connecticut Building was modeled after Benjamin Tallmadge's home in Litchfield, built in 1775 as the first Colonial-style mansion in the Connecticut colony. Tallmadge was an officer in the Continental Army during the American Revolution and served much of his tenure in the army on George Washington's staff. Washington entrusted Tallmadge with the supervision and eventual execution of Major John André, the infamous British spy. The Connecticut Building was in the New England part of the exposition grounds, now a parcel belonging to the naval air station. The building was used as a private residence after the exposition, and in 1934, it was moved to Dillingham Boulevard. It is presently serving as the principal residence of Commander Naval Air Force Atlantic Fleet.

The USS *Monitor* monument, situated in front of the Connecticut State Building, was photographed on November 8, 1907. There was an exact reproduction of the *Monitor* and *Virginia* (*Merrimack*) duel at the exposition. The inclusion of the exhibit and the statue were fitting not only as part of the historic record of Hampton Roads, but Sewell's Point, which had been the primary viewing spot of the famous battle between the ironclads during the Civil War. (Courtesy of the Hampton Roads Naval Museum.)

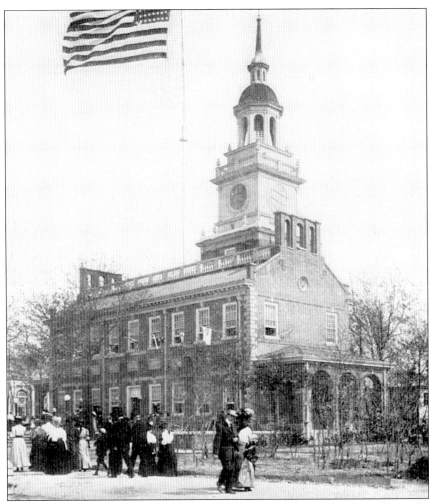

The Pennsylvania Building is a faithful one-third reproduction of Independence Hall, the nation's first capitol, where the Liberty Bell hung, and now Pennsylvania's most revered historic building. Two Pennsylvania governors, Samuel Whitaker Pennypacker (1903–1904) and Edwin S. Stuart, were responsible for the state's magnificent and lasting contribution to the Jamestown Exposition. The building, then located at the corner of Willoughby (Dillingham) Boulevard and Commonwealth (Farragut) Avenue, was completed in May 1907. The architects of the reproduction were Brockie and Hastings, of Philadelphia, and the builder was the Hanley-Casey Company. The clock in the tower chimed so loudly, it could be heard throughout the exposition grounds. The building had many important visitors, including descendants of signers of the Declaration of Independence, Daughters of the American Revolution, Colonial Dames of America, Sons of the American Revolution, and the Society of Colonial Wars, all of whom used it for parties and conventions. Rosa Neilson Wharton, of Philadelphia, served as hostess of the Pennsylvania Building. Pennsylvania Day was celebrated on October 4, 1907. The building was sold after the exposition for $2,000, but its estimated real estate value was placed upwards of $13,000, with a renovation cost of $7,500. The Pennsylvania Building was converted to an officers' club on the naval station after it was acquired by the Navy in 1917 and remained set aside for that purpose until 1975. From 1979 to 1994, the building was home to the Hampton Roads Naval Museum, but has since been renovated and restored to use as a flag officers' club.

The image shown here is the original Independence Hall at the corner of Sixth and Chestnut Streets, Philadelphia, a nice comparison to the replica built for the exposition. This miniature postcard was inscribed on the back by a young sailor, who remarked that a guide showed him and his shipmate, Millet, Independence Hall on October 20, 1914.

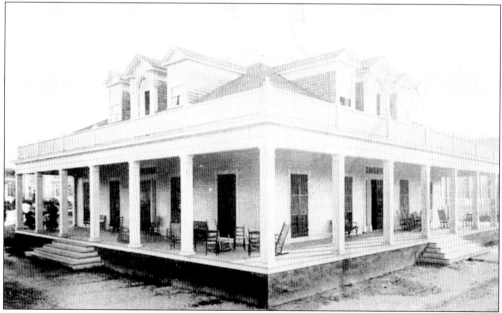

The City of Richmond Building was built to care for people from that city and most especially to invite tourists and visitors to visit historic Richmond and enjoy the sights of Virginia's capital city. The building was run by the Richmond Chamber of Commerce and was located near the state buildings of Massachusetts and New York. J.H. Chataigne served as host of Richmond's building. During the exposition, it served as the headquarters for Petersburg Day and Richmond Day.

The City of Baltimore Building, situated on Powhatan Street, was a short walk from the west gate of the exposition grounds. Businessmen of the city of Baltimore erected the building to showcase the importance of their city as a manufacturing and jobbing center, and for the entertainment of thousands of visiting Baltimoreans. Baltimore Day was celebrated June 27 and led by Governor Edwin Warfield and Mayor J. Barry Mahool. Four excursion steamers brought most of the 3,000 Baltimoreans and Marylanders, the rest arriving by a Chesapeake & Ohio Railway. The song "Baltimore" was sung for the first time on the city's day. H.F. Baker served as chairman of the Baltimore committee, which planned and executed the city's participation.

The North Dakota Building was in the western group of state buildings near Willoughby Boulevard. North Dakota was the most distant among the states represented at the exposition by a building, and it was also the only state represented by a single commissioner: C.A. Everhart, of Fargo, North Dakota. Everhart so wanted his state to participate, he paid for the building of the North Dakota Building himself, retaining ownership of the structure until the Navy acquired it from him.

C.A. Everhart, his wife, and young son, Henry, greeted guests to "The Land of the Dacotahs." Little Henry, shown here, was frequently referred to as "the mascot of the Jamestown Exposition," his youthful spirit and enthusiasm for the world's fair in Hampton Roads as infectious as that of his father. The North Dakota Building was a small house standing behind the Maryland Building and was situated on the corner of Dale and Powhatan Streets. It has remained in its original location since 1907.

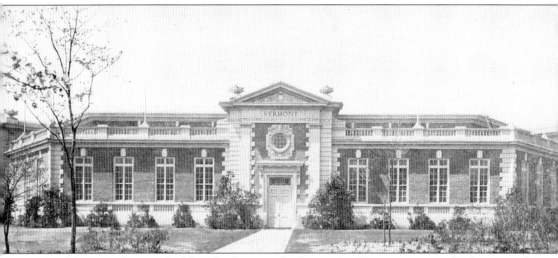

In addition to the state buildings built across the Jamestown Exposition grounds, there was also a States' Exhibit Palace, fronting Spottswood Circle, opposite the Arts and Crafts Village, and state exhibits in the History Building. The States' Exhibit Palace contained elaborate exhibits from many of the states, including Vermont, shown here, and the History Building contained artifacts and documents from a fair number of the exposition's participating states. Maryland had on display in their history exhibit documents that included the 110 names of those who came in the *Ark* and the *Dove* with Governor Leonard Calvert, and shown for the first time together at the Jamestown Exposition. In addition, there were included in Maryland's display, the letter sent back on the *Ark*'s return trip to England giving a description of the voyage and an original bill of lading beginning with the phrase: "Shipped by the Grace of God."

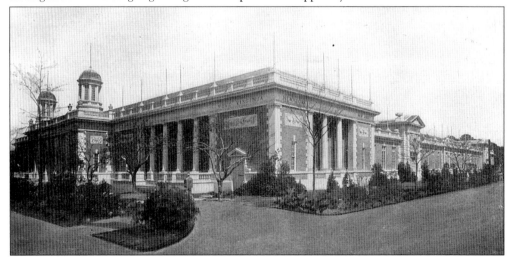

The States' Exhibit Palace provided visitors many hours of pleasure studying and comparing the agricultural products of the states that participated in the exposition. The building, 300 by 500 feet, was to the right of Lee Parade as visitors entered the main entrance of the exposition area. Among the states having large and well-developed exhibits were North Carolina, South Carolina, Connecticut, Oklahoma, California, Missouri, New Hampshire, West Virginia, Georgia, Mississippi, Louisiana, Maryland, Kentucky, Ohio, Vermont, New Jersey, and Virginia. Several railway systems had exhibits as well, notably the Seaboard, the Norfolk & Western, the Chesapeake & Ohio, the Southern Railway, and the Norfolk & Southern.

Douglas H. Thomas Jr., of Baltimore, a member of the exposition company's board of design, was the architect of the Maryland Building. The cornerstone was laid on September 7, 1906, making the building among the few that were completed in time for the exposition's opening day, April 26, 1907. The building was dedicated on April 27, and Maryland Day was celebrated on September 12, with Governor Edwin Warfield (1904–1908), depicted here, officiating both events. The building was furnished with unique furniture and decorative pieces, most of which were mahogany Chippendale and Heppelwhite pieces. There was even a sideboard that had belonged to Francis Scott Key, composer of "The Star-Spangled Banner." Charles M. Stieff loaned an original Stieff piano. The art throughout the building was equally impressive and included a portrait of Thomas Johnson, governor of Maryland who had nominated George Washington to be commander-in-chief of the Continental Army, and a bust of Sidney Lanier, the work of Baltimore sculptor Ephraim Keyser.

The Maryland Building stands on its original site, next to the Virginia Building. The Maryland Building was sold for $2,000 after the exposition. It was seldom lived in and was owned by a realty firm until 1917. The structure was remodeled in 1917 to accommodate multiple quarters.

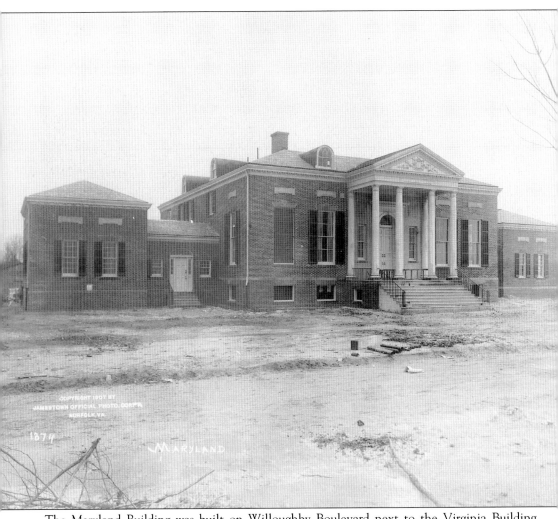

The Maryland Building was built on Willoughby Boulevard next to the Virginia Building, facing Hampton Roads. It is a reproduction of Homewood, the city home of Charles Carroll (1737–1832) of Carrollton, a signer of the Declaration of Independence and Roman Catholic. Carroll built Homewood in 1802 on Charles Street. Johns Hopkins University buildings are constructed on the same architectural style as Homewood, and today, Homewood serves as the home of the university's president. Upon his death in Baltimore on November 14, 1832, Carroll was the last surviving signer of the Declaration of Independence. While the exterior of the Homewood reproduction is true to the original design, the interior of the building was a reproduction of the old senate chamber in the statehouse in Annapolis, where George Washington resigned his commission as commander-in-chief of the Continental Army.

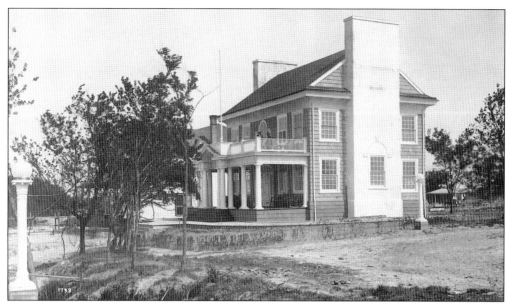

The Delaware Building was located at the extreme eastern end of Willoughby Boulevard near the Commercial Pier, and was the oddest-looking structure on the grounds, with two extraordinarily large chimneys on either side. The arrangement of the interior was also unlike any other house on the exposition grounds. One half was a large room reaching from ground floor to roof, while the other half had floors and was divided into rooms. A reproduction of a Colonial-style homestead found near Wilmington, the building was drawn by architect William Draper Brinckle, also of Wilmington.

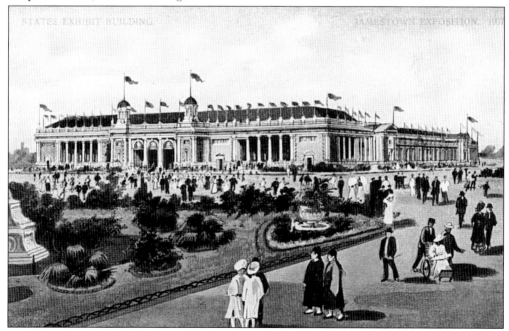

The States' Exhibit Palace, shown here in a hard-to-find postcard, was an exquisitely constructed edifice. The postcard was made in Germany for A.C. Bosselman & Company, of New York.

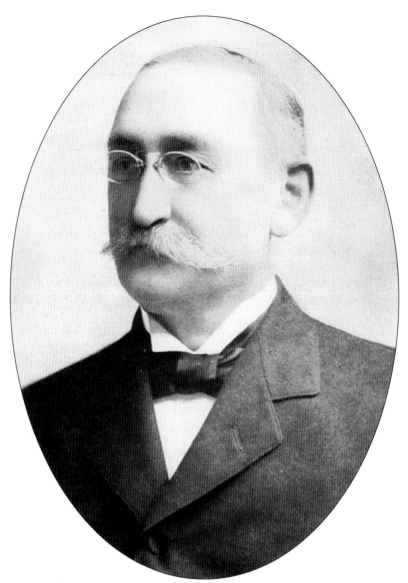

All of the state of Delaware's artistic works, including paintings, drawings, photographs, and sculptures, were removed from the capital at Dover and shipped to Norfolk, where they were hung on the walls or placed in reception areas of the state's exposition building. The artifacts brought to Norfolk included portraits of Delaware governors from George Reed in 1777 to Preston Lea, governor at the time of the exposition, to the bell usually on display in the statehouse in Dover. This bell was brought by Thomas Rodney from England to Delaware in 1763, and rung in 1774 to let citizens know the British had closed the port of Boston. The bell was rung again in 1787 to announce that Delaware had ratified the Constitution, the first state to do so. Included among documents on display was the official document of the first ratification of the Constitution of the United States, framed and hung in the building's exhibit hall. In the sitting room was a picture of Lord De La Ware, in whose honor the state was named. The Delaware Building was originally located on the old Chambers Field, part of Naval Air Station Norfolk, but in 1934 it was moved to its current location at the corner of Dillingham Boulevard and Bacon Street. Governor Preston Lea, of Delaware, is shown here.

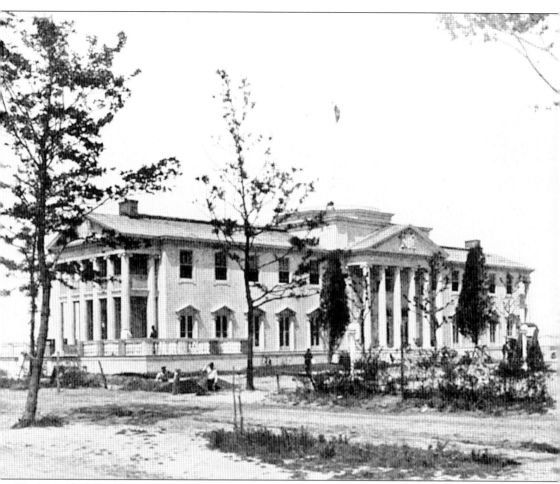

The New York Building was a particularly grand structure, sitting very close to the water's edge on the east end of Willoughby Boulevard. Construction began in January 1907, and the building was not complete when the exposition opened. The New York Building was the first of a number of state buildings that extended eastward from the Grand Basin along a beautiful driveway skirting the shore. The building fronted Willoughby Boulevard, while its rear exposure abutted on the shoreline facing Old Point Comfort. Clarence Luce, of New York City, New York, was the building's architect, and though he designed it in a Colonial style, the final product had strong Italian overtones. The New York Building was officially opened by President Theodore Roosevelt on June 10, 1907, and on July 4, a reception in the building was hosted by Governor Charles Evans Hughes and Prince Wilhelm of Sweden, heir to his nation's throne. New York Week was celebrated the first week of October.

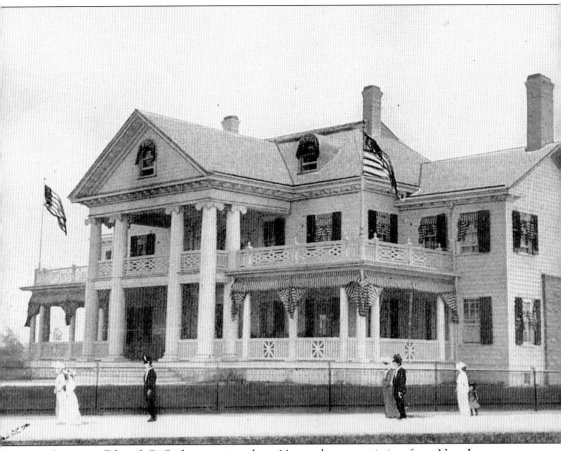

Governor Edward C. Stokes appointed an 11-member commission from New Jersey, a group which met for the first time in the Trenton statehouse in January 1906, and for the second, on Washington's birthday in a special meeting held at the Virginia Club in Norfolk. New Jersey's contribution to the exposition included this replica of George Washington's headquarters at Morristown, located east of Bennett Circle on Pocahontas Street. The builder of the New Jersey Building was R.C. Strehlow & Company, and the architect was George E. Pool, state architect. New Jersey's edifice adhered to the Colonial Revival style, which predominated the exposition, but it was also a close copy of the edifice erected by the state at the Chicago exposition and closely resembled New Jersey's headquarters at St. Louis. New Jersey Day was held October 17, 1907. The New Jersey Building was not standing at the time the Navy purchased the land and buildings on the former exposition grounds in 1917. (William H. Lee, photographer.)

The New Hampshire Building, shown here on a postcard printed by the American Colortype Company, of New York, for the Jamestown Amusement & Vending Company, Inc., of Norfolk, as postcard No. 132 in the series, was a reproduction of the home of John Langdon, built in 1784 in Portsmouth, New Hampshire. Langdon devoted his fortune to the cause of the American Revolution, and fought at Bennington and Saratoga. Governor Langdon was a delegate from his state to the Continental Congress of 1775 and 1776, and in 1783, and to the Constitutional Convention of 1787; United States senator and first president of the United States Senate from 1789 to 1801; and governor of New Hampshire from 1805 to 1809 and from 1810 to 1811. Langdon's Portsmouth, New Hampshire residence is currently the property of the Society for the Preservation of New England Antiquities. Woodbury Langdon, a New York descendant of John Langdon, paid for the replica to be built for the Jamestown Exposition. The New Hampshire Building was the first of the former state buildings to be sold to an individual for use as a residence after the exposition. The Navy moved the house in 1934 from old Chambers Field to its present location on Dillingham Boulevard, where the house serves as the quarters for Commander Naval Base Norfolk and the Mid-Atlantic Region. (Courtesy of the City of Hampton.)

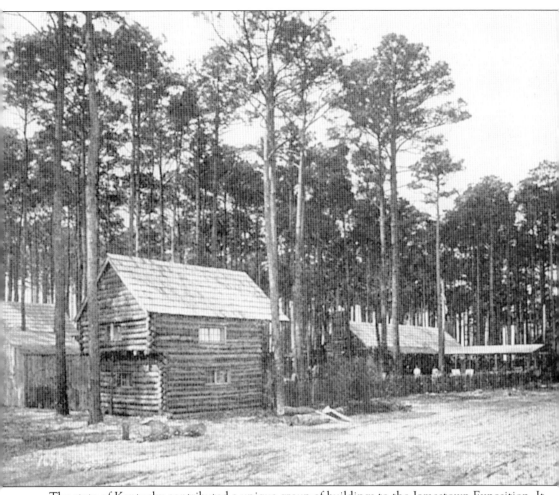

The state of Kentucky contributed a unique group of buildings to the Jamestown Exposition. It was a reproduction of the fort erected in 1775 by Daniel Boone, the pioneer woodsman, in Madison County. Upon each corner of the fort was a block house, and the whole cluster of buildings made an attractive and remarkable exhibit in a pine grove at the west end of Willoughby Boulevard. Logs were contributed by farmers to build the fort along the line of the Chesapeake & Ohio Railway, which transported the logs free of charge. The fort opened on May 18, 1907, and Kentucky Day was celebrated on July 16. The Kentucky State Commission was extremely generous to the orphans of Norfolk. On Saturday, October 5, 150 orphans were treated to a day of rides, food, and fun by the Kentuckians. The Kentuckians were equally generous to their Tennessee counterparts. The Kentucky delegation considerately permitted Tennessee the use of the fort for the celebration of Tennessee Day on October 25. Tennessee did not appropriate money to construct a building at the exposition. The Kentucky buildings no longer exist because they burned soon after the exposition was over. The location in today's terms would have placed the fort immediately west of Maryland Avenue on Dillingham Boulevard.

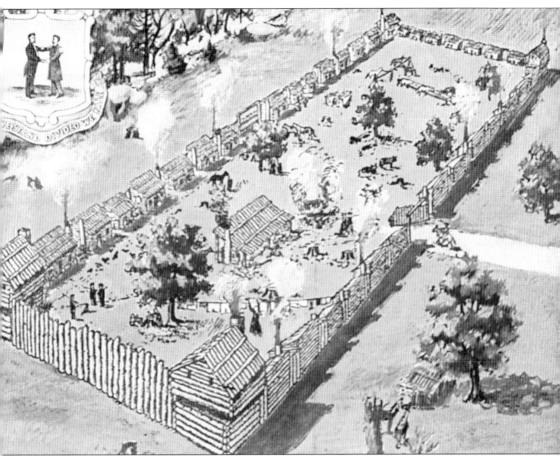

This official Jamestown Exposition souvenir postcard, No. 133 in the Jamestown Amusement & Vending Company series, depicts Kentucky's contribution to the state buildings on the grounds. Daniel Boone's fort was one of the most popular attractions at the exposition. Daniel Boone (1734–1820) first visited Kentucky in 1767, and returned there two years later with his brother and several others to hunt and trap. He explored the region extensively, was captured twice by the Native Americans, and worked for Richard Henderson's Transylvania Company. By 1775, he brought a settlement party and his own family to live in the territory, blazing an extension of the Wilderness Road over the Cumberland Gap through the Allegheny Mountains. This exploration led to the establishment of three important towns, one of which was Boonesborough, later spelled Boonesboro, on the Kentucky River. Kentucky was at one time a county of Virginia, and in 1776, Boone was made captain of the militia. In later years, he would serve in the Virginia legislature. Boone was a hero of the frontier, who can be legitimately credited for extending the new nation's boundaries beyond the Alleghenies.

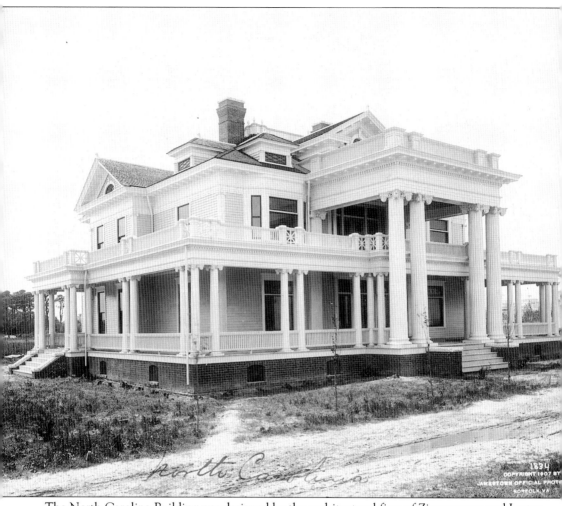

The North Carolina Building was designed by the architectural firm of Zimmerman and Lester of Winston-Salem, North Carolina, and built by J.E. Elliot and Brother of Hickory, North Carolina. Construction of this extraordinary statehouse began in January 1907. Built and finished with North Carolina native yellow pine, the building was completed on June 6, delayed by bouts of unsuitable weather conditions, though it was used before the official opening. On May 20, cadets of the North Carolina Military Academy entertained guests with a band and vocal concert, and to accommodate their stay, the North Carolina Building was opened and readied for their occupation. It is said that one of the rooms of the building was furnished by Edith Vanderbilt, wife of George Vanderbilt, of Biltmore, near Asheville, North Carolina, while another room was supplied with furniture from Mebane, North Carolina. Governor Robert Brodnax Glenn (1905–1909) and the people of North Carolina were particularly proud of the magnificent statehouse.

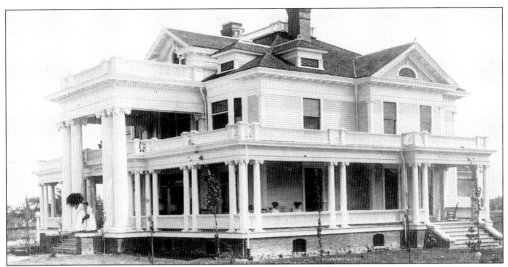

The North Carolina Building was originally located at the eastern end of the grounds, surrounded by New England buildings. The Navy acquired the statehouse from Theodore J. Wool, whose residence it had become soon after the exposition. The Navy moved the building to its present site from old Chambers Field in 1934, and soon after there was a fire in the attic. The fire did little damage to the building's sturdy yellow pine. The building is unrecognizable today as the house that once graced the exposition. It is used to house part of the Naval Base Norfolk Senior Bachelor Officers' Quarters. The house is located nearest the corner of Dillingham Boulevard and Farragut Avenue.

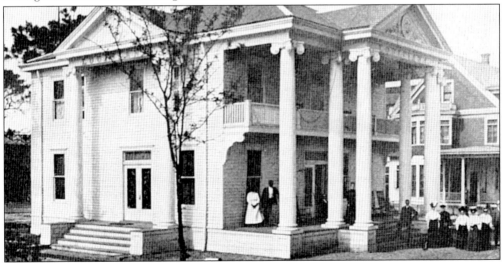

The Louisiana Building was one of the most prominent and comfortable statehouses constructed for the exposition. The house contained a collection of portraits of governors, French, Spanish, and American, 46 total, which hung on its interior walls. The "Pelican State" building resembled a Creole plantation, as it was built with upper and lower porcheses or galleries, as the people of New Orleans called them. The Mississippi River plantation house occupied a site across from the present location of Delaware House, on the corner of Bacon Street and Dillingham Boulevard. It is no longer in existence. The governor of Louisiana at the time of the exposition was Newton Crain Blanchard (1904–1908). Due to the death of Blanchard's wife, Louisiana Day was canceled on August 22.

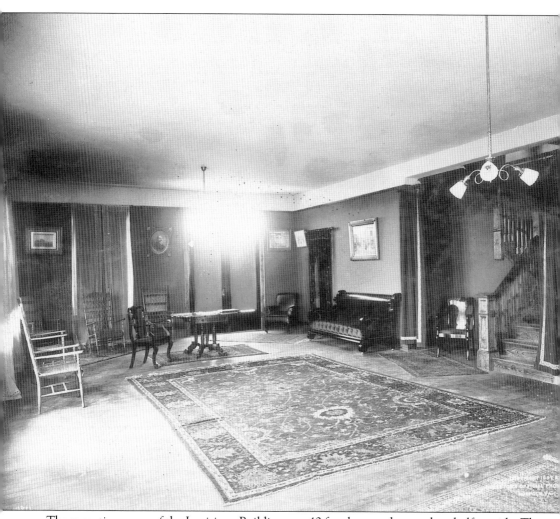

The reception room of the Louisiana Building was 40 feet long and more than half as wide. The color scheme was a delicate green with furniture of old mahogany upholstered in red plush and morocco leather. There were a few writing desks for the ladies and a large reading table, typical of reception and sitting rooms in the Deep South. Old paintings and pastels represented the artistic works of several of Louisiana's finest artists, and all portrayed Louisiana scenes. "A Section of the French Quarter," drawn by William Woodward, showed in the distance the famous cabildo and the old St. Louis Cathedral. "An Old Court" by Gertrude Roberts Smith was reminiscent of a famous French Quarter restaurant. Among the many exquisite works of art was John Pemberton's "Cane Cart" and "The Praline Woman," and at the center of the room, there was a winding stairway of long-leaf pine, hard finished.

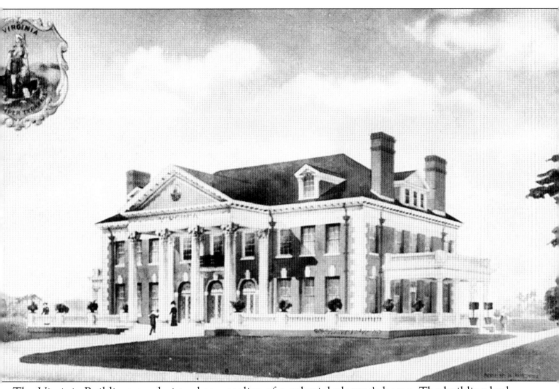

The Virginia Building was designed as a replica of a colonial planter's home. The building had its beginnings under Governor Andrew Jackson Montague (1902–1906), who oversaw its initial appropriations through the General Assembly. The Virginia Building was designed by the Norfolk architectural firm of Breese & Mitchell, and Henry Monk was the builder. Ground was broken for the building's construction in September 1906, and on September 19, the cornerstone was laid by the wife of Claude A. Swanson, governor of Virginia at the time of the Jamestown Exposition and later secretary of the Navy under President Franklin D. Roosevelt. The Navy acquired the Virginia Building from Deal Land & Lumber Company in 1917. The Honorable Joseph Deal, then a congressman from Virginia's Second District, had made the building his residence. The Virginia Building, now known as Virginia House, presently serves as the primary residence of the Commander-in-Chief, United States Atlantic Fleet. The postcard image shown here was an official souvenir postcard of the Jamestown Exposition, No. 121, published for the Jamestown Amusement & Vending Company.

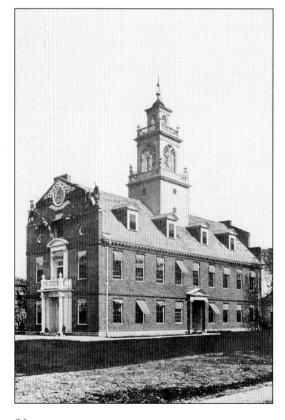

Governor of Virginia Claude A. Swanson and his wife requested guests to join them at the Virginia Building on the Jamestown Exposition grounds, Tuesday evening, 9 to 11 p.m., on September 10, 1907, for the purpose of meeting the governors of Rhode Island and Ohio.

The Massachusetts Building was a reproduction of the old statehouse in Boston in colonial times. Standing at the head of State Street, the financial center of New England, the original statehouse is adorned with emblems of British authority including the lion and the unicorn decorating the front of the building, bygone symbols of royal governance of the American colonies. The Massachusetts Building was constructed of brick and furnished with Colonial-reproduction furniture. At the time of the exposition, Curtis Guild Jr. was governor of Massachusetts, serving as chief executive from 1906 to 1909. Massachusetts Day was observed on August 13. The building was unoccupied, for the most part, after the exposition, and in poor condition after the Navy acquired it. The building was on Willoughby Boulevard in an area east of Commonwealth (now Farragut) Avenue, and it is no longer standing.

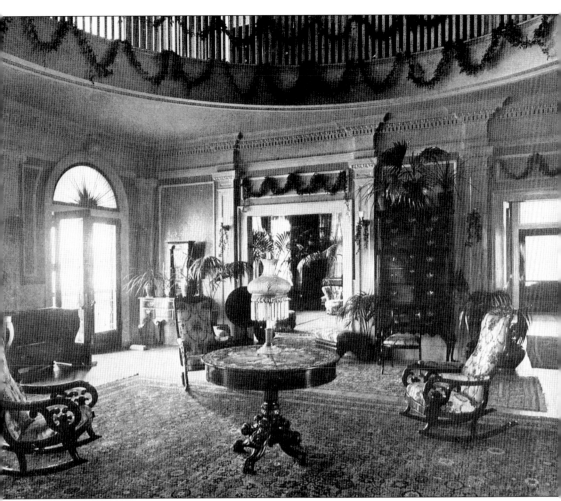

This is an interior view of the Virginia House, strikingly elegant and attractive. The building's interior reflected a spacious colonial design, its great square entrance hall sitting in the middle of the building. Through the hall's ceiling, a well opened, permitting visitors to view sections of the upper and lower floors at the same time. The hall walls were paneled with buff, silk-finished paper, and the wooden wainscoting and plastered pilasters were enameled white, while the cornices were tinted a pale cream. All the floors on the first floor were covered with oriental rugs; adorning the hall and its circumjacent rooms was rare antique furniture, loaned to the Virginia state building. The building's entrance doors were of leaded glass set in mahogany casements. Brass knobs bearing the seal of Virginia completed the elegant detail of the front entrance. Governor Claude A. Swanson and his wife opened the social season surrounding the exposition with an elaborate evening reception in the Virginia Building on April 25, 1907.

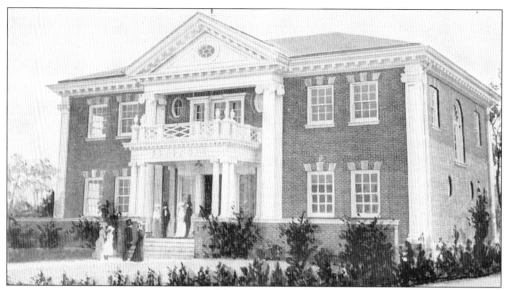

The Illinois Building was located on Bennett Circle, just east of the Massachusetts Building. A groundbreaking ceremony was held on December 5, 1906. Illinois's statehouse was designed by W. Carby Zimmerman, the state's architect, and the builder was Thomas E. Young & Company, of Chicago. Governor of Illinois Charles S. Deneen (1904–1908) appointed a native Virginian and resident of Illinois, Colonel J.A. Humphrey, as secretary of the Illinois State Commission to the exposition. Humphrey's wife was selected as hostess of Illinois' statehouse, but it was the couple's children, "The Little Humphreys," who stole the hearts of visitors. The children are shown at left. Illinois Day was held September 14. At the time the Navy acquired the building in 1917, it was the home of James G. Womble. The Navy eventually moved the building from its original location in 1934, placing it on Powhatan Street.

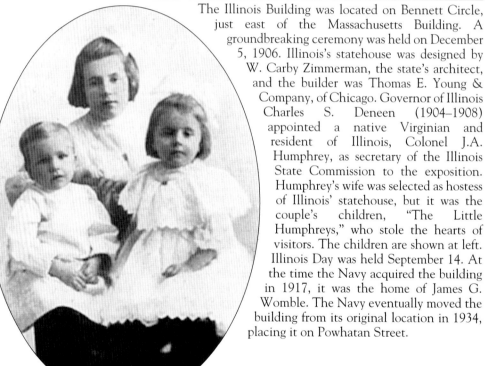

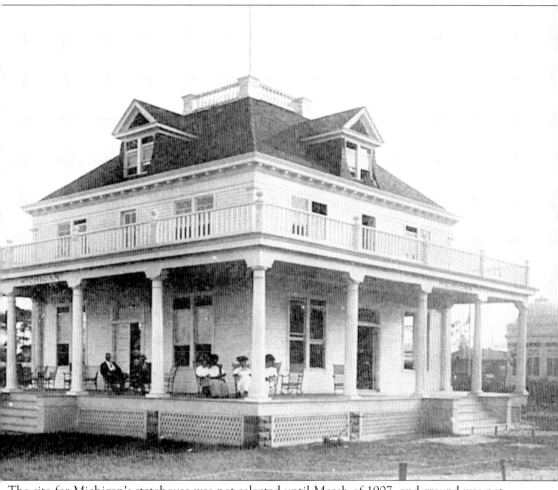

The site for Michigan's statehouse was not selected until March of 1907, and ground was not broken until the first week of May. Due to inclement weather, carpenters did not begin construction until the middle of June. The Michigan Building, located on Bennett Circle, was designed by Norfolk architect H. Irving Dwyer, who died before the statehouse's completion on September 1. The building is a good example of a great number of edifices that were not completed until the exposition was near its end. The governor of Michigan, Fred Maltby Warner, formally opened the statehouse on September 11, acknowledging with regret that the opening was not sooner. The Michigan Building actually opened later than any other state building. Though the Michigan board of managers had negotiated with Grand Rapids furniture factories to furnish the building, this did not occur due to the fact the exposition was nearly over when the statehouse reached completion. Shortly after the exposition, the building was purchased from the state and moved to a lot fronting Willoughby Boulevard near the future site of the Navy's old Chambers Field. Tucked between the old Connecticut and Rhode Buildings, the Michigan Building was occupied by its owner. The Navy subsequently moved the house to Dillingham Boulevard in 1934.

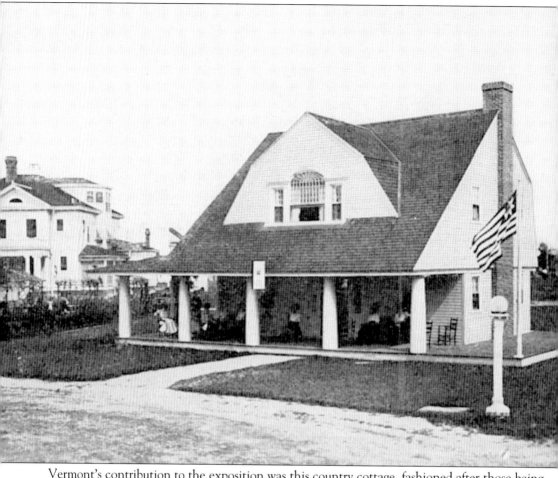

Vermont's contribution to the exposition was this country cottage, fashioned after those being built by summer residents in the state's recreational areas. Surprisingly, the Vermont commissioners chose a woman architect, Josephine Wright Chapman, of New York City, a native Vermonter. The Hanley-Casey Company built the house, which was finished in the middle of June. Vermont Day was September 18. After the exposition, the Vermont Building was bought from the state by an owner who moved it to a site fronting Pocahontas Street, on what was old Chambers Field. In 1934, the Navy moved the house to Dillingham Boulevard, but it is nearly unrecognizable as the building patrons visited during the Jamestown Exposition. The pronounced porch across the front of the structure was removed in 1940 to extend the living and dining rooms and include a fireplace. The original fireplace was removed.

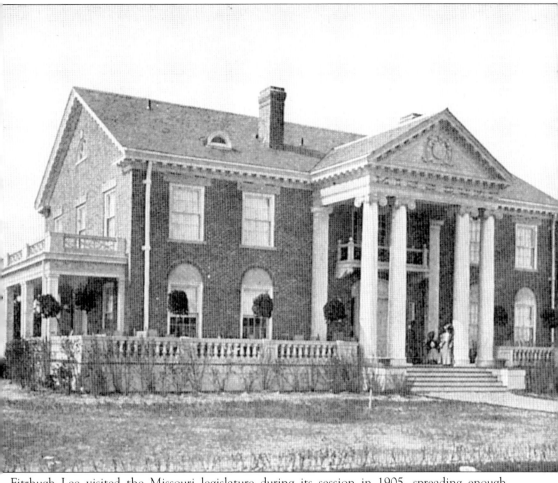

Fitzhugh Lee visited the Missouri legislature during its session in 1905, spreading enough diplomatic persuasion among its members that the Missourians would later appropriate sufficient funding to construct one of the finest statehouses on the exposition grounds. A prestigious location at the corner of Willoughby Boulevard and Dale Street was selected for the Missouri Building, much to the liking of Governor Joseph Wingate Folk (1905–1909). The Missouri State Commission issued a contract on September 11, 1906, to Dunnavant & Company, of Norfolk, Virginia, to construct its state headquarters from plans and specifications prepared by the architectural firm of Mariner & LeBeaume, of St. Louis. The Colonial-style brick edifice, the pride of Missouri, was formally opened on May 26, 1907. The Missouri Building was the location of a luncheon given in honor of Mary Custis Lee, daughter of General Robert E. Lee, on September 12, Virginia Day. The building was one of the few state buildings equipped with a fully functional kitchen and dining room, and because of this, the Missourians entertained many of the prestigious visitors who came to Hampton Roads for the event, including Governor Charles Evans Hughes, later Chief Justice Hughes, of New York, who was a guest for a breakfast party. Missouri Day was held on September 21. The building was later owned and occupied by R.S. Brooks before it was bought by the Navy. The Missouri Building remains on its original site.

The Rhode Island Commission, responsible for the participation of their state at the Jamestown Exposition, was photographed in 1907. The members of the commission included, from left to right, the following: George Batchelor; William Payne Sheffield; Dennis H. Sheehan; Justice John Taggard Blodgett, of the Supreme Court of Rhode Island; and Joseph P. Burlingame. These gentlemen were the first state commissioners to visit the exposition site. The commissioners were responsible for one of the largest state buildings, facing nearly 100 feet on Willoughby Boulevard. The Rhode Island Building was privately owned before the Navy purchased it in 1917. The Navy moved it to Dillingham Boulevard in 1934, where today it forms the eastern half of the Senior Bachelor Officers' Quarters on the naval base. There is no resemblance to the original structure, a disappointing end to a once-magnificent piece of architecture.

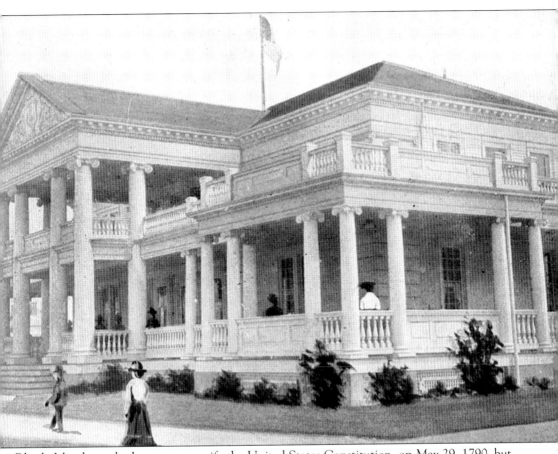

Rhode Island was the last state to ratify the United States Constitution, on May 29, 1790, but the first to appropriate funds for the Jamestown Exposition. The state's commissioners selected architect Edwin T. Banning, of Providence, to reproduce the "Nutmeg State's" first capitol building as the state's contribution to the exposition. The Hanley-Casey Company, of Chicago and Norfolk, erected the statehouse, which was required under contract to be completed by February 1, 1907, for occupancy. This goal was achieved, setting a record for completion among all the participating states. (William H. Lee, photographer.)

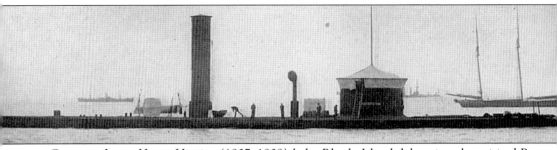

Governor James Henry Higgins (1907–1909) led a Rhode Island delegation that visited Rear Admiral Robley D. Evans's American Battle Fleet in Hampton Roads on April 29, the day before their state building's dedication. The Rhode Islanders were received by Evans aboard USS *Connecticut* before proceeding to the battleship USS *Rhode Island*, where they presented Captain C.G. Bowman with a reproduction of the deed that conveyed "the great Island of Acquidneck," to "Mr. Coddington and his friends" for "forty fathoms of white beades." The document, dated March 24, 1637, was signed by the Sachems of the Narragansetts, Canonicus and Miantonomah, and witnessed by Roger Williams. The delegation also visited two other vessels in Evans's fleet, both of which bore state patronymic: *Canonicus* (shown here, top), an old Civil War monitor, and *Miantonomah* (pictured below), a harbor defender.

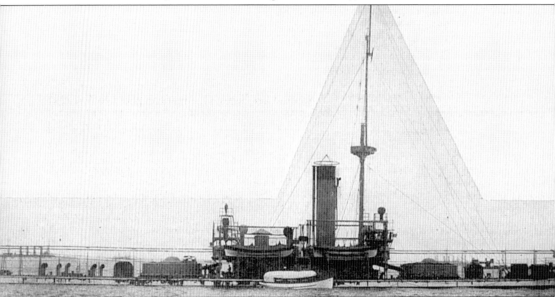

Six

THE GREAT
WHITE FLEET

"And what of thee, O Lincoln's land? What gloom
Is darkening above the Sunset Sea?
Vowed Champion of Liberty, deplume
They war-crest, bow they knee,
Before God answer thee."

—From *England to America*, 1911
Katharine Lee Bates(1), American poet (1859–1929)

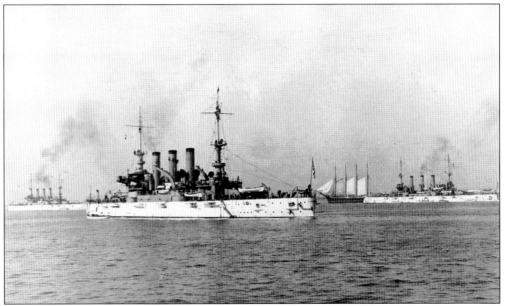

Ships of Great White Fleet lay at anchor in Hampton Roads, December 1907. The around-the-world cruise presented its own set of problems for the United States Navy. The logistics of getting the ships into Hampton Roads was one of the greatest challenges. The Navy also had to have the ships repaired and painted; outfitted with new fire-control equipment; and supplied with thousands of tons of coal and cruise provisions.

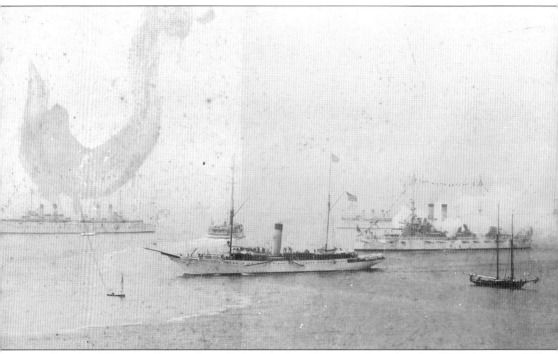

President Theodore Roosevelt, tucked safely aboard his presidential yacht, USS *Mayflower* (PY-1), was being saluted by the ships of his Great White Fleet when C.E. Waterman took this panoramic picture. The *Mayflower*, a luxurious steam yacht with a prodigious history of her own, is in the left foreground. The presidential yacht was constructed in 1896 by J. and O.

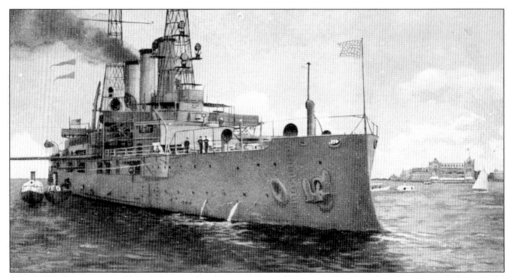

The USS *Connecticut* (BB-18) served as Rear Admiral Evans's flagship for the around-the-world cruise. The battleship, shown here on a postcard, was manufactured in 1907, prior to the *Connecticut* being painted white and surmounted with the bow decoration indicative of all the ships of the Great White Fleet. The Hotel Chamberlin is in the background of the postcard. (Courtesy of the City of Hampton.)

Thompson, Clyde Bank, Scotland, and bought by the United States Navy from the estate of Ogden Goelet. She was commissioned at the New York Navy Yard on March 24, 1898, with Commander M.R.S. McKensie as her first commanding officer. (Courtesy of the City of Hampton.)

The reciprocating steam engine on the USS *Louisiana* (BB-19) was commonplace of the type of propulsion employed on all the dreadnoughts that constituted the Great White Fleet. The third *Louisiana* was laid down February 7, 1903, by Newport News Shipbuilding & Drydock Company, of Newport News, Virginia, and commissioned on June 2, 1906, with Captain Albert R. Couden commanding.

Mayflower to Malla

The *Mayflower* had obviously been acquired by a Navy about to go to war with Spain, thus she joined Rear Admiral William T. Sampson's squadron off Key West, Florida, less than one month after commissioning. During action with Sampson's fleet off Cuba, *Mayflower*, as a steam frigate, captured the Spanish schooner *Santiago Apostol*. This was only the first in a string of *Mayflower*'s successful conquests at sea. After the war, in early 1899, *Mayflower* steamed to New York where she was decommissioned on February 2, and fitted for special service in Puerto Rican waters. Recommissioned on June 15, 1900, *Mayflower* and her crew headed to San Juan where she served as the headquarters for the first American territorial governor, Charles H. Allen, who had no buildings from which he could govern at that time.

By 1902, the *Mayflower* had become the flagship for Admiral George Dewey, and in November of the following year, the yacht remained in Panamanian waters during that country's revolution. The *Mayflower* was the vessel that carried Secretary of War William Howard Taft to Europe in 1904 on an inspection tour of the West Indies. Decommissioned at New York on November 1, 1904, *Mayflower* was refitted as a presidential yacht. When the *Mayflower* was recommissioned on July 25, 1905, Commander Cameron McRae Winslow was in command. The yacht sailed almost immediately to Oyster Bay, Long Island, New York, to serve as the vessel on which President Theodore Roosevelt prepared the peace conference ending the Russo-Japanese War. Aboard *Mayflower* on August 5, Roosevelt brought the Russian and Japanese delegations together to sign a peace accord. The *Mayflower* played a key role in peace negotiations throughout Roosevelt's presidency, a chapter in the president's political history that eventually won him the Nobel Peace Prize.

The *Mayflower*, a chameleonic vessel that went back and forth in its uses under the American flag, was a dispatch boat off Santo Domingo in 1906, before returning to service as a presidential yacht and remaining in that capacity until 1929. Most of the royal families of Europe were entertained at one time or another aboard this historic vessel. President Woodrow Wilson used the *Mayflower* to conduct much of his courting of Edith Bolling Gait, his future first lady.

Mayflower was not removed from presidential service until she was decommissioned on March 22, 1929, by order of President Herbert Hoover, who determined that *Mayflower* was simply too costly to operate. While tied to the pier at the Philadelphia Navy Yard on January 24, 1931, the former presidential yacht was severely damaged by fire. The Navy sold the *Mayflower* on October 19, 1931, to Leo P. Coe, an agent for Frank P. Parish, a wealthy financier known widely as "the boy wizard of La Salle Street," Chicago's Wall Street. Parish was in the process of having the *Mayflower* completely restored by Henry J. Gerlow, Inc., of New York City, New York, when he lost his fortune on the stock market. Gerlow fled the country, and the *Mayflower* sat idly by, waiting for a new owner. A new owner would not come along for many years.

The United States had entered World War II before anyone took a serious interest in the *Mayflower*. The War Shipping Administration bought her from Broadfoot Iron Works, Inc., of Wilmington, North Carolina, and on July 31, 1942, renamed her the *Butte*. *Butte* was transferred to the United States Coast Guard on September 6, 1943, and recommissioned, again, *Mayflower* (WPE-153) on October 19. As a Coast Guard vessel, *Mayflower* patrolled the East Coast looking for German U-boats, escorting coastal shipping, and working as a radar training ship at the naval bases at Norfolk and Boston. The *Mayflower* was decommissioned on July 1, 1946, but her amazing history did not end. Whether she was a chameleon or a cat with nine lives, *Mayflower* was sold to Frank M. Shaw on January 8, 1947, for use as an Arctic sealer. While making way for sealing waters between Greenland and Labrador in early March, *Mayflower* caught fire off Point Lookout and had to return to Baltimore, Maryland. After being repaired, *Mayflower* was bought by Collins Distributors, Inc., in early 1948, refitted with a new boiler, and documented as *Malla* under the Panamanian flag. The *Malla* ostensibly worked

coastal trade in the Mediterranean, but sailed secretly from Marseilles, arriving on September 3, at Haifa, Palestine, with Jewish refugees on board. The *Malla* carried former passengers of the ill-omened *Exodus*, which had been turned away from Palestine in the summer of 1947.

"Gimpy Evans"

Rear Admiral Robley Dunglison Evans was born at Floyd Court House in Virginia on August 18, 1846. He was a midshipman at the United States Naval Academy in Annapolis, Maryland, when war broke out between the North and South in April of 1861. Evans remained at the Academy, graduating in 1863, before proceeding to active duty with the Union fleet. Though Evans participated in both attacks on Fort Fisher, North Carolina, during the Civil War, it would be the second that proved the most life-altering to a young Navy ensign. On the morning of January 15, 1865, Ensign Evans was among one hundred sailors and marines aboard the USS *Powhatan*(2) who volunteered to join detachments from other Union vessels in a land attack on Fort Fisher, the Confederate earthworks at the entrance to the port of Wilmington. As Union forces made their way toward the fort, Evans was shot in the thigh. Wounded and in great pain, Evans hurriedly wrapped his wound with a handkerchief and pressed on, moving with more determination as he closed the distance between himself and Confederate positions. Evans was shot several more times, finally taking a wound to the knee, which at minimum would be crippling, and left unattended, could have been fatal. Had it not been for a valiant and daring rescue by a detachment from the USS *Pequot*, led by Acting Ensign Anthony Smalley, Evans might have died in the field of battle. Instead, the *Pequot* crewmen took wounded survivors to the USS *Nereus* where they were stabilized and transferred to the USS *Santiago de Cuba* for transport to the Portsmouth Naval Hospital in Portsmouth, Virginia. Though it may not be

evident in the photograph, Evans managed to keep both his legs, despite the suggestion of a Navy surgeon that the young ensign have his leg amputated. The suggestion of amputation was completely out of the question as far as Evans was concerned, so much so that when the surgeon made a stronger suggestion that the amputation take place, Evans pulled a pistol from under his pillow and threatened to shoot the messenger if he did not drop the idea of cutting his leg off. The surgeon concluded that Evans would die anyway, the leg having been so badly injured from the shot to the knee. In the end, Evans did not die, but he was left with a permanent limp and chronic pain. The limp was particularly pronounced during Evans's tenure in command of the Great White Fleet, the stress of the voyage almost more than the aging admiral could undergo. Ensign Evans was medically retired from the United States Navy shortly after the Civil War, but this retirement was not to last. Evans appealed to the United States Congress to reinstate his commission in the Navy and won.

Evans came into his own as an officer in the United States Navy many years after his first "retirement." Placed in command of the USS *Yorktown* (Gunboat 1) at Valparaiso, Chile, in

1891, during the United States' strained relations with Chile, then-Commander Evans's actions in defiance of the Chilean navy during this tour of duty earned him the nickname for which he is famous, "Fighting Bob." As a captain, he went on to command the USS *Iowa* (BB-4) in Rear Admiral William T. Sampson's fleet off Santiago, Cuba, in the war with Spain, taking an active role in the Battle of Santiago de Cuba opposing Admiral D. Pascual Cervera Y Topete's (1839–1909) Spanish fleet, on July 3, 1898. The *Iowa*, the largest and newest battleship in the American Navy, was famous for having fired the first gun at Cervera's ships as they tried unsuccessfully to break out of the port of Santiago de Cuba. The engagement on July 3 was fought with honor on both sides, and one incident near the end of the battle, which remains a testament to that fact, was the rescue of the commanding officer, 23 of his officers, and 248 of her enlisted crewmen from the disabled Spanish warship *Vizcaya*. Evans made certain that five of Captain Eulate's dead were buried with honors, the wounded tended to properly, and the remaining Spanish sailors treated with respect as they were transferred to prisoner-of-war facilities. There were no casualties among the *Iowa* crew, and this was of great importance to "Fighting Bob" Evans. His son, a midshipman, was serving under him on the *Iowa* at that time.

By 1901, Evans was a rear admiral, subsequently serving as commander-in-chief of the Asiatic Station from October 1902 to 1904. He was returned to a commanding role in the Atlantic Fleet after his return from the Orient. "Fighting Bob" was named commander-in-chief of the Atlantic Fleet for the around-the-world tour in 1907. The aging and crippled admiral was compelled by his poor health to relinquish command of the American Battle Fleet to Rear Admiral Charles Stillman Sperry. He spent the remainder of his life incapacitated by illness and racked with pain from the crippling injuries of his youth. Evans finally passed away in 1912.

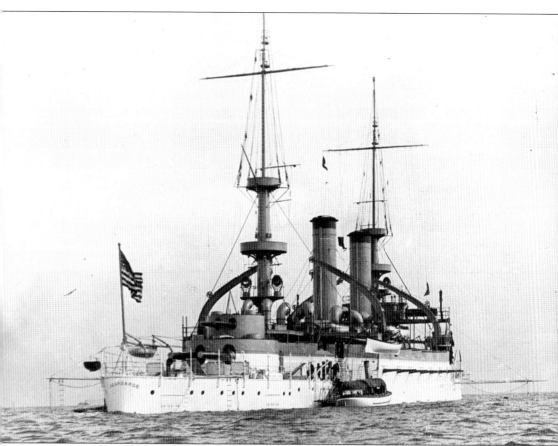

The USS *Kearsarge* (BB-5) was the second ship to be so named. She was launched March 24, 1898, by Newport News Shipbuilding and Drydock Corporation of Newport News, Virginia, and commissioned on February 20, 1900, with Captain William M. Fogler in command. *Kearsarge* first served as the flagship of the North Atlantic Station, cruising up and down the Atlantic seaboard and into the Caribbean, parting only briefly to act as flagship of the European Squadron in the summer of 1903. Though *Kearsarge* would be relieved of her duties as flagship of the squadron by the USS *Maine*, she remained in operation with the fleet. At the time of the Jamestown Exposition, *Kearsarge* was attached to the Second Squadron, Fourth Division, and departed with the Great White Fleet's battleships and support vessels on December 16, 1907, from Hampton Roads. Her commanding officer on the world cruise was Captain H. Winslow. She was ultimately decommissioned on May 10, 1920, for conversion to a crane ship and redesignated AB-1 on August 5, 1920. Since the name *Kearsarge* was to be given to an aircraft carrier, the battleship-now-crane-ship was officially renamed *Crane Ship No. 1* on November 6, 1941. It is remarkable that this pre-dreadnought Navy ship continued to make major contributions to the war effort in World War II. *Crane Ship No. 1* lifted guns, turrets, armor, and superstructures for new classes of battleships, cruisers, and aircraft carriers, her carrier work conducted at the San Francisco Naval Shipyard. She returned to the Boston Naval Shipyard in 1948, where *Crane Ship No. 1* ended her long and illustrious naval career. *Crane Ship No. 1*'s name was stricken from the Navy record on June 22, 1955, and the ship sold for scrap on August 9, 1955.

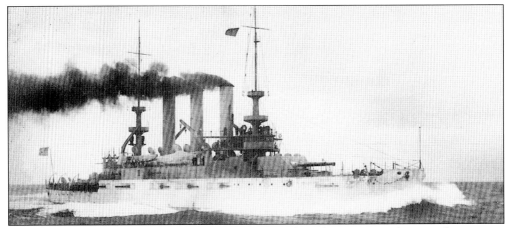

The *Missouri*, shown here during her sea trials in October of 1903, was to become the epitome of modern warfare, if only for a brief time. Commander of the American assault on Manila, Territory of the Philippines, the immortal Admiral George Dewey, once said if he had had the *Missouri* during that conflict he, "could have taken care of the Spanish fleet without further assistance."

The *Missouri* was delivered by Newport News Shipbuilding and Drydock Company, and commissioned, on December 2, the day after this photograph was taken. The intricate decoration on the bow of the *Missouri* (shown here) was typical of the work done on ships of that era.

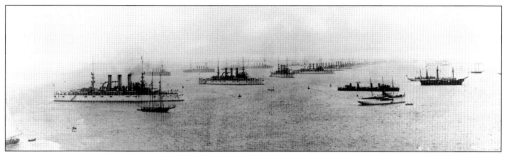

Taken on December 16, 1907, this image depicts the Great White Fleet assembled for its departure from Hampton Roads harbor. Sixteen first-class battleships, the pride of the United States Navy, with 14,000 officers and crew, were destined to go in excess of 40,000 miles around the globe. Rear Admiral Robley D. "Fighting Bob" Evans commanded the fleet from his flagship, USS *Connecticut* (BB-18). *Connecticut*'s commanding officer was Captain H. Osterhaus. (Photographer unknown.)

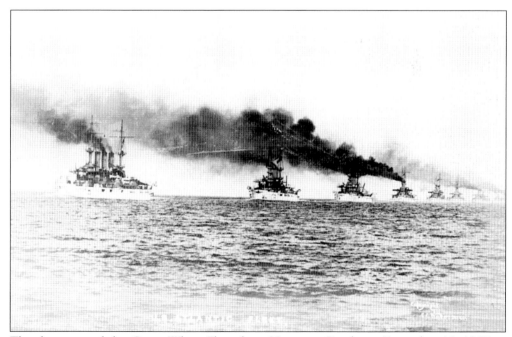

The departure of the Great White Fleet from Hampton Roads on December 16, 1907, is pictured on this postcard. The American fleet was leaving Old Point Comfort when C.E. Waterman of Phoebus, Virginia, took the picture. (Courtesy of the City of Hampton.)

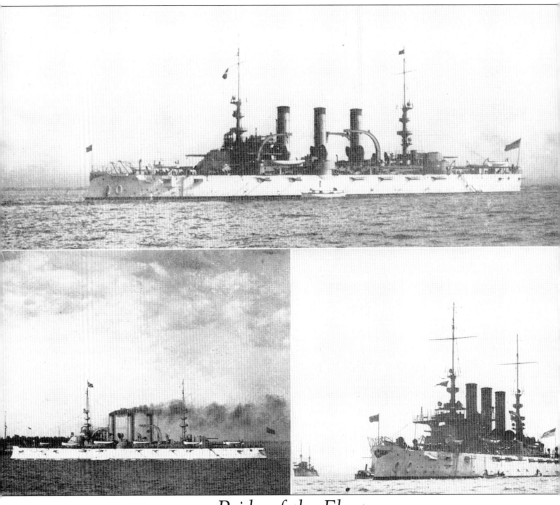

Pride of the Fleet

Three of the United States Navy's finest first-class battleships lay at anchor off the exposition in the photographs shown here. The USS *Virginia* (BB-13) (top) was one of the newer additions to the Navy at the time this picture was taken in 1907. The *Virginia* was built at Newport News Shipbuilding and Drydock Corporation, and launched on April 6, 1904. The *Virginia*'s sponsor was Gay Montague, daughter of the governor of Virginia. She was commissioned on May 7, 1906, with Captain Seaton Schroeder in command. The USS *Virginia* did her shakedown cruise in Lynnhaven Bay, Virginia, as well as off the coast of Newport, Rhode Island, and Long Island, New York, before coaling at Bradford, Rhode Island, on August 9. The *Virginia* held a special place in President Theodore Roosevelt's heart. After running standardization trials on her screws off Rockland, Maine, the ship maneuvered in Long Island Sound before anchoring off Roosevelt's home on Oyster Bay, Long Island, September 2–4, 1906, for a presidential inspection. The *Virginia* successfully operated as part of the fleet, and when it was time to head to Hampton Roads on April 10, 1907, to participate in the Jamestown Tercentennial Exposition, she detached from Cuban waters and sailed for the Roads. *Virginia* was subsequently reviewed in Hampton Roads by President Roosevelt June 7–13, before heading northward to participate in target exercises off Rhode Island. The pride of *Virginia* returned to Hampton

Roads on December 6, where she spent the next ten days preparing for the around-the-world cruise. The cruise was regarded by the president as a dramaturgic gesture to the Japanese, who had emerged as a world power to be reckoned with, and who had participated with great distinction in the Jamestown Exposition. Roosevelt's Great White Fleet proved a major success. The cruise left eight days before Christmas 1907 and returned on George Washington's birthday, February 22, 1909. *Virginia* was part of the First Squadron, Second Division, and her commanding officer was Captain Seaton Schroeder.

The USS *Georgia* (BB-15) (bottom left), also a first-class battleship, was built at Bath, Maine, by Bath Iron Works. The *Georgia* was launched on October 11, 1904, and commissioned at Boston Navy Yard on September 24, 1906, with Captain R.G. Davenport in command. After an abbreviated shakedown period, *Georgia* joined Division 2, Squadron 1 of the Atlantic Fleet as the flagship of her division. Though she departed Hampton Roads on March 26, 1907, for Guantanamo Bay, Cuba, for gunnery practice with the fleet, and later to Boston for repairs, *Georgia* returned to Hampton Roads in time to participate in opening ceremonies for the Jamestown Exposition. President Theodore Roosevelt was one of many dignitaries to review the fleet on June 10, 1907, and June 11 was declared Georgia Day at the exposition aboard the first-class battleship. The following day, *Georgia* steamed with the fleet to Cape Cod Bay for target practice. During target drills on July 15, a powder charge ignited prematurely in *Georgia*'s aft 8-inch turret, mortally wounding ten officers and enlisted men, and injuring another 11. Despite this tragedy, *Georgia* returned to Hampton Roads between August 16 and 21 to participate in the tercentenary of the landing of the first English colonists. After this event, *Georgia* rejoined the Atlantic Fleet for battle maneuvers before mooring at League Island, New York, on September 24, for a much-needed overhaul. The *Georgia* arrived back in Hampton Roads on December 7, 1907, with 15 other Navy battleships, a torpedo boat squadron, and numerous transports as part of the Great White Fleet. President Roosevelt reviewed the fleet on December 16.

The USS *Rhode Island* (BB-17), built at Fore River Shipbuilding Company, Quincy, Massachusetts, is pictured here bottom right. The ship was named for one of the original 13 states, which owes its name to the Dutch navigator, Adrian Block, who called the future colony Roade Eylant, Dutch for Red Island, upon first sighting the red clay on its shores in 1614. Captain Perry Garst was in command of *Rhode Island* when she was commissioned on February 19, 1906. *Rhode Island* joined Division 2, Squadron 1, Atlantic Fleet, on January 1, 1907, departing for Guantanamo Bay a couple of weeks ahead of *Georgia* for gunnery practice and squadron operations before returning to Hampton Roads to participate in the Jamestown Exposition as well as the Great White Fleet's final departure on its round-the-world cruise.

The *Georgia* was decommissioned on July 15, 1920, and eventually sold for scrap on November 1, 1923. *Rhode Island* was decommissioned at Mare Island on June 30, 1920, and rendered incapable of further war service on October 4, 1923, in accordance with the Washington Treaty limiting naval armaments, and sold for scrap on November 1, 1923. The *Virginia* was decommissioned on August 13, 1920, struck from the Navy record and placed on the sale list on July 12, 1922, though she was subsequently reclassified and transferred to the War Department on August 6, 1923, for use as a bombing target. Army Brigadier General William "Billy" Mitchell sunk *Virginia* and her sister ship, USS *New Jersey*, while the pre-dreadnoughts lay at anchor 3 miles off Diamond Shoals lightship, located off Cape Hatteras, North Carolina, on September 5, 1923, in experimental bombing attacks with Army Air Service Martin bombers. One observer later penned, after witnessing the devastation of a single 1,100-pound bomb on the *Virginia*: "Both masts, the bridge; all three smokestacks, and the upperworks disappeared with the explosion and there remained, after the smoke cleared away, nothing but the bare hull, decks blown off, and covered with a mass of tangled debris from stem to stern consisting of stacks, ventilators, cage masts, and bridges."

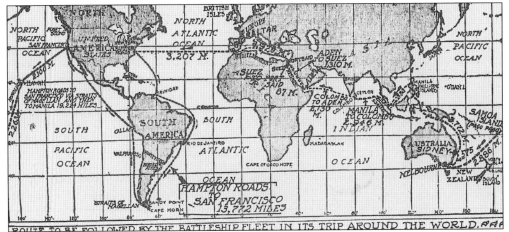

This was the route followed by the battleships of the Great White Fleet in its trip around the world from December 16, 1907, to February 22, 1909.

When the Fleet Went Around the World

The grandest of naval expeditions undertaken by the United States in the early twentieth century was assembled in Hampton Roads in December 1907 as the final curtain call of the tercentennial celebration of the Jamestown Exposition, which had wound down at the end of November. President Theodore Roosevelt's Great White Fleet came to symbolize America's world-power status and the years of work it took to build a navy greater than any other nation, even if the fleet was outmoded before it ever sailed. In its heyday, the American Battle Fleet was not only the greatest fighting force on the high seas, but also one that made tremendous strides toward a more proficient and efficient United States Navy. The fleet's 14-month circumnavigation of the globe would be the longest cruise ever made by the fleet of any nation, and one of Roosevelt's greatest calculated risks.

In the waning days of 1906, the warlords of Japan had begun to rattle their swords in the name of their emperor, anxious to test their rapidly increasing military strength beyond the waters of the eastern hemisphere. The aggressive nature of Japan's military was nothing to be ignored. The Japanese had successfully defeated the Imperial Russian Navy in the Russo-Japanese War the year before, and Roosevelt was eager to demonstrate to the emperor that the American Battle Fleet would not be such an easy target. The British Navy, the United States' elder on the high seas, exhibited little interest in Japan. Great Britain was having troubles in her colonial possessions and commonwealth, which far outweighed proving naval superiority to an emerging military power in the East. Besides, in the British admiralty's opinion, there was no clear sign of a war looming with Japan, and the admiralty's resources were better spent combating unrest in England's own territories. Roosevelt was on his own.

The American Battle Fleet was so designated in December 1907, in preparation for its departure from the Roads on the 16th of the month. The fleet consisted of two squadrons, the first made up of the battleships *Connecticut* (BB-18), *Maine* (BB-10), *Louisiana* (BB-19), *Missouri* (BB-11), *Virginia* (BB-13), *Rhode Island* (BB-17), *New Jersey* (BB-16), and *Georgia* (BB-15), and the second comprised of the *Alabama* (BB-8), *Illinois* (BB-7), *Kentucky* (BB-6), *Kearsarge* (BB-5), *Ohio* (BB-12), *Minnesota* (BB-22), *Iowa* (BB-4), and *Indiana* (BB-1). There

were five capital ships, five cruisers, six destroyers, torpedo boats, and numerous auxiliary ships accompanying the main battle force. The hulls of all the American Battle Fleet ships were painted white as opposed to Navy hazegray, thus the name Great White Fleet. Within the two squadrons were four divisions. The first division consisted of the *Connecticut*, *Kansas*, *Vermont*, and *Louisiana*; the second, of the *Georgia*, *New Jersey*, *Rhode Island*, and *Virginia*; the third, of the *Minnesota*, *Ohio*, *Missouri*, and *Maine*; and, the fourth, of the *Alabama*, *Illinois*, *Kearsarge*, and *Kentucky*. Each of the ships was given instructions to steam 400 yards astern of the division's lead ship and on down the line, though this would not hold true for the duration of the deployment. Often the fleet would go to two columns, and again to four. Whatever the sailing order, this armada of 16 battleships made an impressive sight. Seven of the 16 battleships were constructed by Newport News Shipbuilding and Drydock Company: *Kearsarge* (Newport News Shipbuilding's Hull 18) and *Kentucky* (Hull 19), both launched March 24, 1898; *Illinois* (Hull 21), which slid down the ways on October 4, 1898; *Missouri* (Hull 25), launched December 28, 1901; *Virginia* (Hull 40), launched April 5, 1904; *Louisiana* (Hull 45), August 27, 1904; and *Minnesota* (Hull 46), which slipped down the ways on April 8, 1905.

Roosevelt, known for his bold diplomacy, was taking a calculated risk with the Great White Fleet, stakes higher than the president's previous ventures on the world stage. Though he would never announce the true objective of the fleet's circumnavigation of the globe, it was Japan, a nation coming into its own in the eastern hemisphere. The Japanese, who had made a tremendous showing at the Jamestown Exposition, shared the world's disappointment and disapproval when the United States government decided to terminate the employment of Japanese cabin boys as the terms of their enlistments ended aboard American naval vessels. Almost immediately, newspapers abroad took the termination of Japanese cabin boys as a sign that Roosevelt's Great White Fleet was preparing to wage war on Japan, even though this suspicion was far from the truth. The American public, and most especially the nation's young men, were responding in the positive to the Navy's recruiting advertisements containing teasers for the fleet going around the world. The *New York Herald* of November 11, 1907, editorialized of Roosevelt's Great White Fleet: "At last our Navy is taking on an international importance, and our young men are responding to the call in unprecedented numbers. Navy officers say they have seen nothing like it before—young men from all over the nation wanting to serve with 'Fighting Bob' Evans and the great American squadron."

The Great White Fleet was commanded on its departure from Hampton Roads by Rear Admiral Robley D. "Fighting Bob" Evans, who was also the first commander in chief of the United States Atlantic Fleet, having assumed the command on January 1, 1906, aboard his flagship, USS *Maine*. On the eve of the fleet's departure, a grand ball was held at the Chamberlin Hotel at Old Point Comfort, culminating with a magnificent fireworks display and a line from Rear Admiral Evans that immortalized the fleet to the American people. Evans declared the fleet ready for "a feast, a frolic, or a fight." Evans knew a great deal about a fight. He brought with him experience that began during the Civil War, when he was present for the Union capture of Fort Fisher, South Carolina. His departure at the helm of the fleet from the deck of his cruise flagship, USS *Connecticut*, was witnessed by an ebullient President Roosevelt from his yacht, *Mayflower*, as the fleet passed out of Hampton Roads on the morning of December 16, 1907. Roosevelt could not have chosen a better tactician nor as good an administrator than Evans, a colorful officer and leader with the charisma to carry the president's message around the world.

The *New York Herald* reported of the American Battle Fleet's departure, "The great, white squadron passed for review in remarkably perfect formation." Newspaper reports of the day reported that as the battleships passed out of Hampton Roads, a young woman leaned over to her escort and remarked, "Have we any Navy left?" In reply, the young man said, "Oh, yes. There's the *Yankton*," but in truth, he had been misinformed. The USS *Yankton* left with the fleet, leaving only the USS *Sylph* in port.

Since it was so close to Christmas when the Great White Fleet departed Hampton Roads, its

ships tried to outdo one another with elaborate holiday decorations as the fleet headed south. With their 14,000 officers and enlisted men, the two squadrons reached the coastal waters of Trinidad on Christmas Eve. Christmas Day was spent in 90-degree tropical heat. Each ship was trimmed with tropical greens from bow to stern, masthead to waterline. The gun turrets and barrels were decked out, too. Officers and enlisted men occupied themselves with sports of all kinds, including boat racing and liberty calls.

The "Sweet Sixteen" celebrated New Year's Eve at sea by crossing King Neptune's domain (see the Domain of Neptunes Rex certificate), the equator, and later rounding Cape Horn at the tip of South America. As the fleet crossed the equator, Neptune, his wife Amphitrite, and their royal court made the rounds of Evans's ships. A red flag with a white sea serpent was broken out at the main to signify Neptune's command of the fleet and the ocean. By the time the fleet reached Rio de Janeiro, Brazil, bluejackets and marines were ready for a lengthy port of call. The Great White Fleet spent two weeks in Rio, at which time they were joined by the torpedo flotilla, the dispatch boat USS *Yankton*, the auxiliary repair ship USS *Panther* (AD-6), the seagoing icebreaker USS *Glacier*, and the mobile stores ship USS *Culgoa* (AF-3).

The around-the-world cruise would continue to be full of significant ports and geographical wonders, including brief stops at San Diego and other California ports of call before the passage of the fleet on May 6, 1908, through San Francisco Bay's Golden Gate, a channel about 2 miles

This certificate, printed around the time of the Great White Fleet's cruise around the world, is a tradition of the United States Navy that continues today. Neptune, the mythological god of the seas, has been paid tribute by sailors since the days of the Vikings, and the American Navy was certainly no different. The Neptunus Rex named on the certificate is the ceremonial majesty who rules over the initiation for all first-time sailors, officers, and enlisted men, crossing the line (the equator). Neptunus Rex is portrayed by the oldest and most distinguished senior Son of Neptune or "shellback" on a Navy ship, and his first assistant is Davy Jones. Initiation was particularly harsh on those who had never crossed the line in the Steel Navy era, though in those days, officers could still buy off their punishment with a gift to King Neptune and his court, usually a liquid beverage of choice. These certificates, usually provided by the Navy command and in some instances quite beautiful, remain prized possessions of sailors.

wide at the mouth of the bay. The distance from Hampton Roads to San Francisco was 13,750 sea miles, a passage made in 61 days and 19 hours.

Evans turned over command of the American Battle Fleet shortly before the fleet's arrival in San Francisco. The fleet continued up to Seattle and Tacoma, Washington, where, after roughly a month, Evans's replacement came aboard. Rear Admiral Charles S. Sperry would first take the Great White Fleet to Honolulu, Territory of Hawaii, and then continue to oversee its circumnavigation of the globe. Toward the end of its journey, the fleet separated at Port Said, Egypt, to visit the Mediterranean ports of Smyrna, Genon, Algiers, Marseilles, and numerous others, regaling Asia, Africa, and Europe with further demonstrations of a polished American Navy. The American Battle Fleet regrouped at the Straits of Gibraltar and headed westward for the Chesapeake Bay in late January 1909. Sperry, headquartered aboard the *Connecticut*, passed in review of President Roosevelt off Hampton Roads on the morning of February 22, a scene reminiscent of the fleet's departure more than a year earlier. Ships filled the Roads, and crowds lined viewing areas along Old Point Comfort and Fortress Monroe, and residents of Norfolk poured from their homes to eagerly await the fleet's arrival. By 11 that morning, the stacks of the formidable armada appeared on the horizon, its return heralded by the *Connecticut*'s sounding of a 21-gun salute.

When Roosevelt's American Battle Fleet departed Hampton Roads, the criteria for its success had been broadly defined. Roosevelt placed his faith in Evans's fleet to project the United States' military might around the world by playing an integral role in the president's "big stick" global policy. This fleet's remarkable journey over 90 years ago made our twentieth-century Navy more proficient, honed sailors' maneuvering skills on the high seas, and greatly improved the efficiency of America's seagoing fighting force. With the passage of 14 months at sea, the fleet had travelled down the Atlantic coast of South America and up to the west coast of the United States, then crossed the Pacific to Japan, visited the nation's territories and protectorates in the region, and returned to the Atlantic by way of the Suez Canal and Mediterranean Sea, steaming an incredible 46,000 miles.

The projection of American naval power was the driving force behind the world tour of the Great White Fleet, not the firepower of its battleships. By the time the fleet sailed from Hampton Roads in December 1907, its ships had already become outdated. The British battleship HMS *Dreadnought*, launched in 1906, was fitted with ten big guns, whereas the "Sweet Sixteen" had only two forward and two aft, typical of battleships of the period in the fleets of most of the world's seagoing navies. The American Navy had two dreadnoughts in service by 1910, the USSs *Michigan* (BB-27) and *South Carolina* (BB-26), with others soon to follow.

Even after its departure, the American Battle Fleet's intention to circumnavigate the globe had not been announced. Roosevelt masked the project as a practice cruise from Hampton Roads to South America until he was ready to reveal his true objective, which was Japan. Once Evans's armada reached South America, it was given time to replenish before transiting to the Pacific coast of the United States and, eventually, onward to Japanese territorial waters. The voyage's real goal was to show Japan, an emerging world power, that the United States Navy ranked second in the world, while the Japanese Imperial Navy remained a distant fifth. Perhaps of equal importance to the President was the fact that America's naval shipbuilding industry was in trouble. Since appropriations were tied up in the United States Congress, the only way to demonstrate the country's need for domination of the high seas was to send out the best the nation had to offer in order to impress the rest of the world—and American legislators. The president's calculated risk paid off in the end because Japan temporarily retreated in the face of the United States' superior naval presence. No hostilities were reported, and the Japanese emperor had entertained the occidentals in sumptuous splendor upon their arrival in Yokohama. The only problems proved to be two outbreaks of cholera and constant fuel shortages. President Roosevelt was later to say: "The most important service that I rendered to peace was the voyage of the battle fleet around the world."

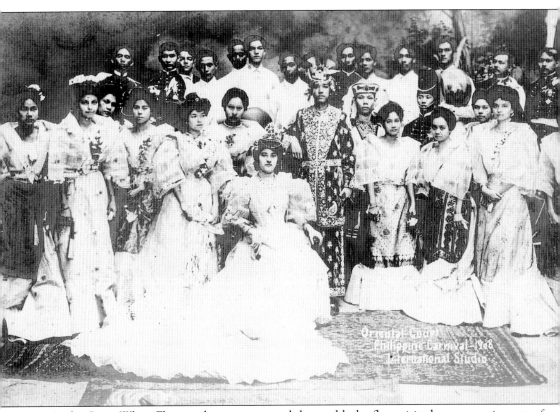

Oriental Court
Philippine Carnival 1908
International Studio

As the Great White Fleet made its way around the world, the fleet visited many exotic ports of call and United States territories, one of which was the Philippines. Rear Admiral Robley D. Evans had given up command of the fleet just prior to the fleet's arrival in San Francisco on May 6, 1908. His successor was Rear Admiral Charles S. Sperry. Sperry took the fleet on its tour of the Pacific. As the battle fleet entered the Territory of the Philippines, it entered the Strait of Basilan, the entrance to Philippine waters, made its way past the American post of Zamboanga and up to Manila. Manila threw a series of carnivals and parties in which Americans, Spaniards, and Filipinos joined in. After leaving the Philippines, the Great White Fleet departed for Yokohama, Japan. The Oriental Court was part of the Philippine Carnival in honor of the Great White Fleet, 1908. The picture on this postcard image was taken by International Studio.

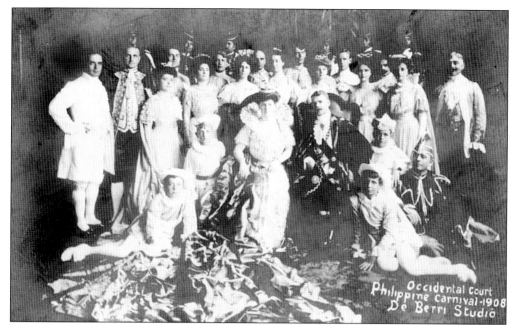

The Occidental Court, consisting of Americans in costume, was another party taking part in the Philippine Carnival of 1908. De Berri Studio took the photograph, which ran on a rare and very collectible photograph postcard.

A crowd of onlookers brave dreary weather at the Chamberlin Hotel in Hampton to catch a glimpse of the return of the Great White Fleet to Hampton Roads on February 22, 1909. This is a rare image from an event that drew the eyes of thousands of people on the armada of ships that went around the world.

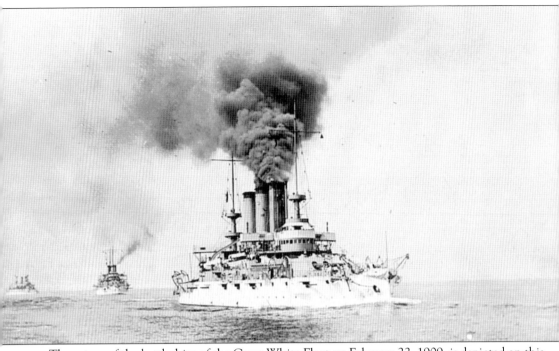

The return of the battleships of the Great White Fleet on February 22, 1909, is depicted on this postcard. After a month had passed, all United States Navy battleships, cruisers and destroyers that made the around-the-world cruise were once again painted Navy haze gray. (Courtesy of the City of Hampton.)

1. Katharine Lee Bates published her poem in *America the Beautiful and Other Poems* (New York: Thomas Y. Crowell Company, 1911). Bates is best known as the author of "America the Beautiful," first published on July 4, 1895, in *The Congregationalist*.
2. The USS *Powhatan*, a steamship, participated in the successful reduction of Fort Fisher, North Carolina, on December 24 and 25, 1864, and its capture, January 13–15, 1865.

Seven

THOSE DARING
YOUNG MEN AND
THEIR FLYING MACHINES

"Nothing will ever equal that moment of exhilaration which filled my whole being when I felt myself flying away from the earth. It was not mere pleasure; it was perfect bliss."

—Professor Jacques Alexandre Cesare Charles, December 1, 1783, after the first free flight in a manned hydrogen balloon.

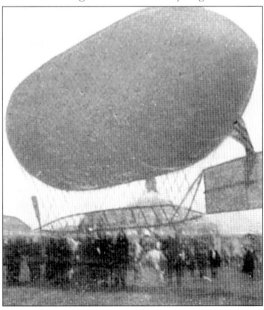

The semi-rigid dirigible (shown here) was flown from the Aeronautic Concourse at the exposition grounds. Airship flights took place from the grounds, much to the delight and excitement of event patrons. On May 21, 1907, Lincoln Beachey made his first successful flight in an airship at the exposition. Beachey was scheduled to fly from the Aeronautic Concourse at eleven in the morning, but owing to high winds, his flight did not launch successfully until six o'clock that evening, when he rose above the crowd gathered around Lee Parade Ground. Circling over the troops, then parading, Beachey travelled over the Auditorium and other large buildings. He then passed over the waterfront and War Path before descending without mishap into the enclosure from which he had departed.

The first flying done at the Jamestown Exposition was not by daring young men and their flying machines, but pigeons. One of the most spectacular flights occurred the morning of May 18, 1907, when more than 6,000 various colored, well-trained homing pigeons were released over the parade ground, going aloft and speeding northward to their homes in New York City, Philadelphia, Cleveland, Buffalo, and other cities. Fortunately, Jamestown Exposition photographers captured the event on film.

Eugene Godet was one of the most important aviators of his day. The Frenchman began, as did his contemporaries, flying balloons and semi-rigid dirigibles, but by 1909, had shifted almost exclusively to piloting fixed-wing aircraft. This photograph was taken in 1907 of a young Godet.

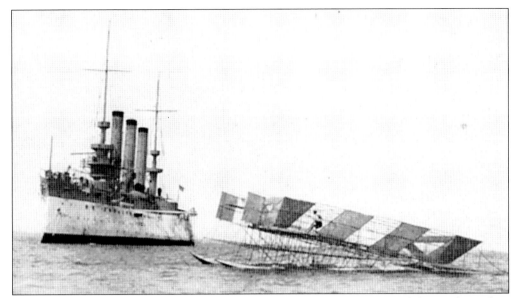

J.G. Maas was attempting to go aloft from the waters of Hampton Roads with his airplane when this rare photograph was taken.

The Aeronautic Building was incomplete when the exposition opened. It was not dedicated until June.

Those Daring Young Men and Their Flying Machines

Those daring young men and their flying machines added a measure of wonder to the Jamestown Exposition of 1907, which no one and nothing else could have achieved. The aeronautics department of the Jamestown Exposition Company consulted with the Aero Club of America in the spring of 1906 to discuss an aeronautical program, inclusive of scientific investigation and exhibition of airships, airplanes, balloons, and kites, for the exposition. Aeronautics was provided a building of its own by the exposition company, which also agreed to furnish free gas for balloon ascensions and to prepay the freight on all exhibits. The Jamestown Aeronautical Congress was organized and significant contributors to aviation research and development at that time were named to its leadership roles. The congress' president was Willis L. Moore, but its secretary was Albert Francis Zahm, the first professor of mechanical engineering at the University of Notre Dame and an aerodynamicist who had built one of the first-ever wind tunnels while pursuing his master of science degree at Cornell University. Zahm had also organized the first International Aeronautical Congress, held in Chicago, Illinois, during the 1893 world's fair. The eminent aerodynamicist was an institution at Notre Dame during the 1880s and 1890s, where he became most famous for his night-time manned glider flights from atop university buildings. Among the honorary advisors to the exposition's aeronautical congress was Octave Chanute (1832–1910), the elder statesman of aeronautics at the turn of the century. Serving on the executive committee were Augustus J. Post, its chairman and world-renowned balloonist, Orville and Wilbur Wright, and Alexander Graham Bell, who had explored the development of airplanes based on tetrahedral cells in a large kite framework as a way of circumventing the Wright Brothers' patents on aircraft design. Israel Ludlow was named superintendent of aeronautics.

The Aeronautic Building was not finished when the Jamestown Exposition opened on April 26, 1907, and, in fact, took several months longer to complete. Dedication ceremonies for the building were held on June 8. Robert H. Sexton, chief of the Department of Congresses and Special Events for the exposition; Augustus Post, chairman of the aeronautics executive committee; Harry St. George Tucker; Admiral C.M. Chester; and Israel Ludlow participated in the dedication event. Chester's speech was particularly important because he openly discussed the possibilities of aircraft being used in warfare and the value of an aeronautic division to the Army and Navy. The Aeronautic Concourse was also delayed in its completion since it was dependent on a readily available supply of gas to float the balloons and air bags on the airships. A 3-inch gas pipeline running from the city of Norfolk to the exposition grounds, a distance of 7.5 miles, was not completed until early June, and all balloon flights were postponed until after that time.

The first aeronautical event of the exposition did not actually involve a man-made aircraft, but flights of pigeons. A pigeon flight on May 9 marked the first airborne activity to occur on the grounds. A flight of 560 pigeons was released for a race to Washington, D.C., and before leaving the grounds, the pigeons circled the concourse twice, and only then did they disappear in the direction of their homing station. Pigeon races to New York City and Philadelphia were also held during the exposition, but Israel Ludlow observed, "it was the Washington pigeons which flew to the west of the grandstand, which was directly north of the releasing point, and New York and Philadelphia birds flew to the east of it, correctly selecting the direction for their home flight to an exact degree corresponding to the points of the compass." A race on May 19 by 23 birds from New York and Philadelphia clocked the frontrunner birds at nearly 59 miles per hour, a remarkably fast time for pigeons. The winning birds came from New York and were owned by Henry Ingram, of Paterson, New Jersey; Paul F. Miller, of Williamsburg, Brooklyn; F.W. Davis, Borough of Manhattan, New York City; Adolph Busch, Borough of Richmond, New York City; J.W. Booth, Essex, New York; and M.G. Meller, Plainsfield, New Jersey. The pigeons from New York beat the Philadelphia homers due in large measure because their instinct was to follow the Atlantic Coast, making the distance in flight shorter and faster.

The period of pigeons was a brief chapter in the exposition's aviation history, but an important one to the success of early aviation research and development, as were studies of all kinds of birds. Israel Ludlow spent many hours watching flocks of carrier pigeons in a barn near his workshop in New York City as he was developing his biplane in 1905, gaining ideas as to the the best way of going aloft. Ludlow fixed on each phase of a pigeon's life, from a mother bird teaching her young to fly, through the flights of mature birds. He actually altered the angle of the wings of his biplane after a day's worth of observing a flock of pigeons. The birds were watched with close attention, the exact angle of their wings when soaring being of chief interest. Another critical design change was to the rudder, tilting it down a little as the pigeon does his tail feathers in flight. Two of the pigeons Ludlow studied extensively were tumblers, birds with the ability to make dizzying dives and right themselves midair. Despite the keen interest of aviation designers in the aerodynamics of birds, the crowds flocking to the Jamestown Exposition wanted to see men and their flying machines at work. Spectators eventually got their wish.

During the last week in May, Lincoln Beachey, a professional aeronaut under the management of Charles J. Strobel, of Toledo, Ohio, made a series of semi-rigid dirigible flights from the Aeronautical Concourse around the exposition grounds, each time landing on Lee Parade. The flights were highly successful and attracted the fixed gaze of thousands of spectators. To some degree, Beachey was unprepared to navigate the obstacles in his path: tall turrets on the War Path and tall stands of pine trees. The battleships in Hampton Roads could clearly see Beachey on his flights. Whenever sailors saw him ascend in his airship over the houses and treetops of the exposition, a general call went up from the ships and officers, and enlisted men rushed to the sides of their vessels to watch the flight of Beachey's airship. The Jamestown Exposition Company's contract with Beachey and Strobel called for a sustained flight of at least 20 minutes. Strobel had engaged Lincoln Beachey and Beachey's brother, Hillary, to build semi-rigid dirigibles in 1906, and it was the Beacheys who Strobel entrusted to fly them in exhibitions. The dirigible Lincoln Beachey was flying at the Jamestown Exposition had a rigid framework underneath and a flexible balloon above. The airship could only get up to about 15 miles per hour.

By early June, Beachey had been joined in the air by Eugene Godet, who brought to the exposition in bond a French semi-rigid dirigible, the most current design being flown in France at that time. On the afternoon of June 7, after a day of hard work spent repairing a broken shaft, the airship was brought out of its building and the engine tested. Though a thunderstorm was rolling in over the treetops, Godet, despite cautions to remain on the ground, went up anyway. With a crowd of several thousand willing to brave a storm and high winds to watch, Godet did not want to disappoint. As he ascended, the wind blew him backwards beyond the concourse. He drifted sideways and dangerously close to a tall windmill near the waterfront. It was at this juncture that Godet regained a modicum of control over the airship, however brief. Godet was again propelled by the wind toward two tall pine trees near the Inside Inn. As the wind carried the airship through the tree branches, Godet struck with such force that the impact broke the propeller blades in half, causing each half to trickle to the ground. His rudder was also completely gone. Without the propeller and rudder, Godet drifted over the roof of the Inside Inn and out over the waters of Hampton Roads. Immediately after clearing the trees, he pulled a safety valve, but struck the water for the first time, about 500 feet from shore. He sank a few inches then rose buoyantly, rising out of the water for a few moments to about 20 feet, then hit again, skipping the water like a pebble across a pond. Godet gradually sunk deeper and deeper as he took on water, travelling over Hampton Roads toward Old Point Comfort, a distance of about 5 miles. Battleships anchored in a line across the Roads had a clear view of Godet's dilemma and sought ways to save the flying Frenchman. Several battleship captains put rescue launches in the water. A launch belonging to the USS *Minnesota* was the first to reach Godet's airship, and its sailors successfully grabbed hold of the drag rope, but were unable to tow the airship against gale-force winds. *Minnesota*'s launch was dragged through the water by Godet's

airship until the airship struck the battleship *Alabama*'s foredeck, where the gas envelope had to be deflated. The envelope was packed and returned to the exposition grounds, but the framework was destroyed and a new one had to be built.

The aeronautical committee had approved what was called a captive balloon concession, operated by Charles J. Strobel. To inflate the balloons, Strobel used a hydrogen generating plant, and this kept the balloons filled. Two balloons were used during the summer, the first of which carried two passengers and the second, three or four people, contingent on weather conditions. Strobel charged $1 a ride, a quarter of which went to the exposition. He ascended with paying passengers between 700 and 1,000 feet, and on clear days, patrons could get a bird's-eye view of Cape Henry, Cape Charles, Virginia Beach, Fortress Monroe, and the church spires of Norfolk, Portsmouth, and Newport News, all of which looked like toy houses in the distance, while the James River and Chesapeake Bay lost themselves far away in the summer haze. Sometimes the balloons were up at the same time as the airships, and Beachey and Godet would skillfully navigate in circular fashion around the balloons for an added crowd-pleaser. Officers and enlisted men in the military talked about the airships being used in "a new arm of the service." Serious discussions, from a scientific standpoint, focused on an airplane or "heavier-than-air" machine being the airship of the future.

In an experiment performed at the Jamestown Exposition, a great kite-like aircraft 40 feet in length and 25 feet wide was built and mounted on boats made of water-tight canvas. During August, an attempt was made to fly this aircraft with J.G. Maas sitting in the pilot's seat (see top of p. 115). A 300-foot rope hawser was attached to the aircraft and to a Navy tug, the USS *Potomac*, but the tug proved too slow to raise the airplane in the air and during the trial, the pontoon boats became hopelessly water-logged. The next trial was made by mounting the aircraft on two 16-oared cutters and a torpedo boat was selected to do the towing work. On the second go, ten soldiers from the Army Signal Corps aided the experiment. Four soldiers sat in the cutters to assist the flight, and J.G. Maas, a professional balloonist, positioned himself in the pilot's seat. Two flags were carried on the test flight, one with a red center and the other with a blue center. The soldiers had instructions to wave the red flag if the aircraft was in trouble, and the blue if the test was going satisfactorily. The aircrew quickly discovered that if the torpedo boat towed the aircraft at 14 to 15 miles per hour, it swamped. The airplane was then towed into Hampton Roads where it could be towed into the wind to gain lift and the torpedo boat could get up to full speed—22 mph. Maas and his crew waved the blue flag valiantly despite the expected outcome. The aircraft took on too much water as the torpedo boat pulled it through the water, and gradually, though the blue flag was still waving, the craft began to sink into the Roads. The blue flag could still be seen above-water as the aircraft dipped below the surface. The torpedo boat hurriedly turned around and picked up the crew, who were uninjured.

The Army Signal Corps members of J.G. Maas's crew were undaunted by their failed attempts to send an aircraft aloft from the water. Instead, they took a different tact. A new airplane was built by soldiers of the Signal Corps and a flight was attempted on Lee Parade. The aircraft was towed by six artillery horses attached to a gun carriage and about 200 feet of rope. On the first trial, the rope broke. On the second and third trials, the airplane rose into the air to 100 feet, and after travelling about halfway across Lee Parade on the third try, it swerved and hit the ground with enough force to destroy the plane. The accident was attributed to a faulty attachment to the bridle of one of the horses.

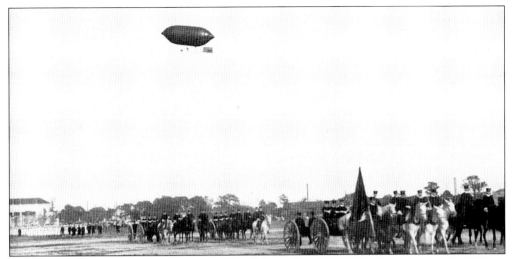

Lincoln Beachey took his semi-rigid dirigible aloft on North Carolina Day, August 15, 1907.

The interior of the Aeronautic Building and some of the members of the Jamestown Aeronautical Congress were photographed in 1907 by Harry C. Mann. Israel Ludlow is the gentleman in the wheelchair (fifth from the left). Augustus J. Post is third from the right and Harry St. George Tucker is sitting fifth from the right, holding the straw hat.

Israel Ludlow, superintendent of aeronautics, was an attorney from New York City, New York, who designed and built a large biplane in 1905 that looked much like a powered kite. Ludlow graduated from law school at the University of Michigan, Ann Arbor, in 1895, and had been practicing law in New York for a decade when he made a hapless flight in the flying machine of his own making. Though not an aerodynamicist or engineer, Ludlow took an interest in aeronautics from his college days and frequently experimented with his notions of powered flight. "There is no reason in the world why man shouldn't fly," Ludlow was quoted as saying in a *New York Times* article from June 6, 1905. "It is probable that his first flights will be short and crude, as the jumps and hops of a young bird are. In time, though, he will spurn the earth, and his movements in the air, like those of a full-grown bird, will be free and untrammeled. When it is, a new world will be opened. The jungles of Africa will be explored. The pole may be gained. War will be a back number." Ludlow was in the process of building his flying machine when interviewed by the New York newspaper. "The framework is of light bamboo, 1 1/4 inches in diameter, and the wings are covered with light canvas, treated with a preparation of linseed oil. The joints are bolted with three 16-inch bolts and bound with light yacht marlin. There are two groups of superimposed aeroplanes placed by pairs in tandem fashion." The young lawyer built his fleet of flying machines in a yard near 300 West End Avenue. The aircraft he built to fly on July 25, 1905, was among them. The flight on July 25 started from the foot of West Seventy-ninth Street and the North River, and though Ludlow ascended, he was unable to control his airplane, and it wrecked. Ludlow was severely injured, but survived. His injuries left him in a wheelchair for the remainder of his life.

Eight

DEVASTATION AND RESURRECTION

"And with the passing of those crumbling walls
Passes as well much that its builders loved;
Hopes, and ideals, habits of reverence,
Beliefs and purposes that gave them strength
And courage to pursue their thorny way.
But symbols change, and what we proudly raise
In its decay, with tender, sheltering clasp,
The ivy of tradition shields from view;
Yet by the old the new springs up to life,
Transmuted in the crucible of Time,
In its alembic fashioned to new moulds,
In substance one, immutably the same.
One love, one grief, on triumph, one regret
Forever stirs the hearts and minds of men,
And one abiding hope, that still we move
Toward purer heights of righteousness and peace."

—From *Virginia*, 1907
Mrs. James P. Andrews, of Hartford, Connecticut

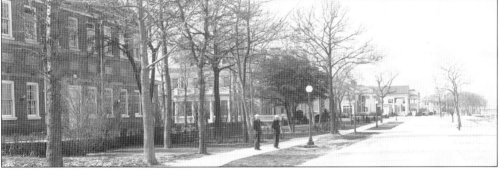

The stately row of former Jamestown Exposition state buildings eventually became known as "Admiral's Row" once the United States Navy acquired the property and began making significant changes to the configuration of Dillingham (formerly Willoughby) Boulevard. The promenade in front of the former state buildings is intact in this 1921 photograph, but hydraulic fill has begun to claim the waterfront on the right. The state buildings, from left to right, include Pennsylvania (left foreground), Virginia, Maryland, Missouri, Ohio, Georgia, West Virginia, and Louisiana.

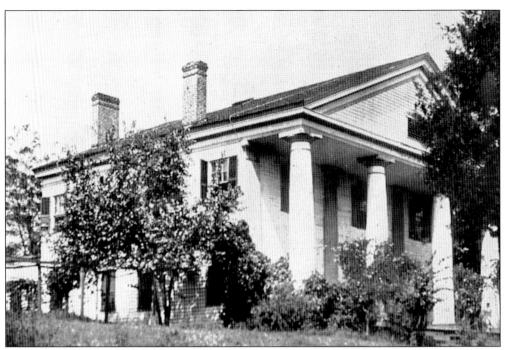

The Georgia Building, photographed many years after the exposition, c. 1915, had fallen into a sad state of disrepair.

The arms of the Government Pier were in ruins by the time this picture was taken about 1915. The Jamestown Exposition might have been a great achievement in its scope and historic perspective but, financially, the entire event was a disaster. The grounds that had taken so much care to plan and construct were left to crumble.

The Jamestown Exposition Corporation a bust, the property passed from private ownership of the buildings and grounds, and eventually to the United States Navy. The boat drill and bathing beach of the United States Naval Operating Base, Hampton Roads, Virginia, are depicted on the postcard shown here. Houses of the exposition are also visible. The house on the far right is the Vermont Building. The image was published about 1917.

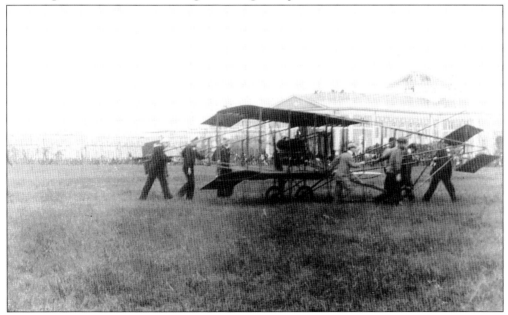

An aviation exhibition by Eugene Barton Ely was held at the old Jamestown Exposition grounds, later site of the Norfolk Naval Station, on November 15, 1910. The aircraft was the Curtiss *Hudson Flyer*, used by Ely the day before on his historic first flight from a Navy ship, the USS *Birmingham* (CL-2), and the first flight from ship to shore. (Courtesy of the Hampton Roads Naval Museum.)

About 1917, Frank J. Conway, a Curtiss Aeroplane Company photographer, took these aerial photographs of the former Jamestown Exposition grounds. Most of the exposition's exhibit halls and War Path buildings had been removed, their footprints about all that remained of the once-impressive tribute to America's first settlement. The statehouses in the image above include the Illinois Building (far left) and next to Illinois, the Massachusetts Building (second from the left). The Auditorium complex is on the far right. In the photograph below, Willoughby Boulevard was still intact. The state buildings were being encroached, however, by the Navy's construction of barracks and training facilities.

The state buildings intact in this Frank J. Conway photograph, taken c. 1917, from left to right include: Maryland, Missouri, Ohio, Georgia, West Virginia, and Louisiana. Dale Street is the road running between the Maryland and Missouri Buildings, while Bacon Street separates the Delaware and Louisiana Buildings. The North Dakota Building is the smaller structure sitting behind the Maryland Building.

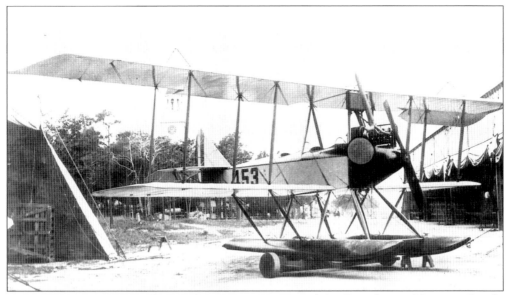

A Boeing Aeromarine seaplane, February 14, 1918, Naval Air Detachment Hampton Roads, sits in the foreground of what aviators of the period dubbed "Tent City." Pennsylvania House, a landmark structure from the 1907 Jamestown Exposition, can be seen in the background. Note the canvas tents and wood-frame structure draped with canvas tarps. These tents house repair facilities for the aircraft, and sometimes double as barracks for enlisted and officer personnel. (Official United States Navy Photograph.)

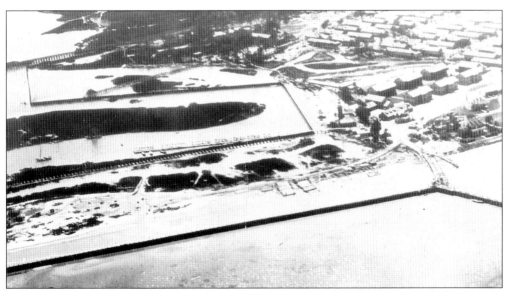

The eastern section of the former Jamestown Exposition grounds, then Naval Air Station Hampton Roads, was rung with bulkheads during the process of land reclamation begun in 1918, when this picture was taken. Several of the former state buildings, as well as the Life-Saving-Station-turned-air-station-tower, are visible in the lower right. (Official United States Navy Photograph.)

There would be three C-series airships assigned to Naval Air Station Hampton Roads, including C-3 (Bureau Number A4120), C-7 (Bureau Number A4127), and C-9 (Bureau Number A4124). C-3, shown here, was manufactured by Goodyear and delivered to Hampton Roads in February 1919, when this photograph was taken. The C-3 was destroyed by fire when a spark from her engine ignited it near Hampton Roads on July 8, 1921. The photograph was taken in the parade field behind the former Jamestown Exposition Auditorium. By the time this picture was taken, the Auditorium housed base communications, the post office, and general administrative offices. The building was destroyed on January 26, 1941, after a fire caused by faulty wiring swept the structure. Rear Admiral Joseph K. Taussig, commandant of the Fifth Naval District, lost his headquarters communication center, post office, district disbursing office, and invaluable records pertaining to critical defense projects. The Auditorium was replaced by Building N-26, former headquarters of Commander, Naval Base Norfolk. (Official United States Navy Photograph.)

The interior of the Recreation Hall, 1919, at the United States Naval Operating Base at Hampton Roads was located in the education building adjacent to the Auditorium Building, both former Jamestown Exposition buildings. (Harry C. Mann, photographer.)

Many years after exposition ended in financial ruin, and just three years after the United States Navy had acquired the land for development of a training center, Harry C. Mann took this photograph in the winter of 1920 showing the rear portion of the Auditorium and its attached wings.

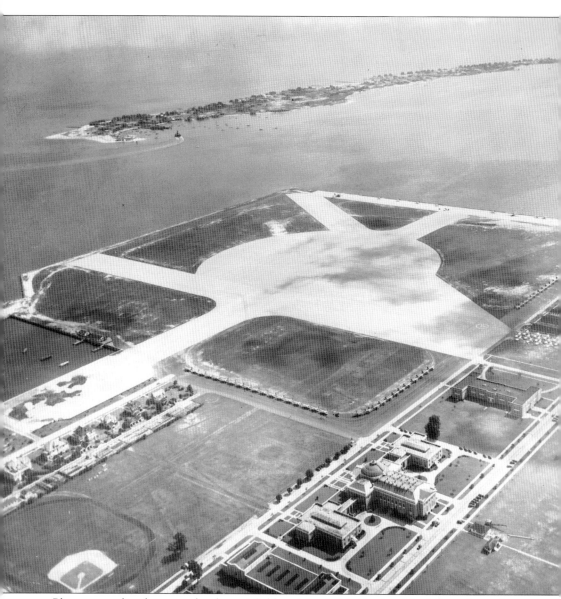

Planes were lined up on the first airfield at Naval Air Station Norfolk to bear the name Chambers Field, July 29, 1939. The ferry from Hampton was arriving at Willoughby (above the field on the left). Chambers Field was named on June 1, 1938, in honor of Captain Washington Irving Chambers, the first officer-in-charge of aviation and director of early efforts to find a home for naval aviation in the Navy. The Navy had moved several of the Jamestown Exposition statehouses in 1934 to accommodate construction of the hard-surface runway and buildings necessary to support a growing air station activity. The former Auditorium and many of the statehouses are visible in this photograph.